MARINE PAINTING

Acknowledgements

The author and the editor wish to thank all those who, through friendship or love of the sea, agreed to set sail with them on this adventure and authorized the reproduction of their works in this book: Gérard Barthélemy, Jacques Coquillay, Christoff Debusschere, Cyril Girard, Bernard Guédon, Iffic, Dan Jacobson, Michel King, Pascal Langevin, Jean-Pierre Le Bras, Emmanuel Lemardelé, Gérard Leserre, Guy L'Hostis, Annie Puybareau, Christiane Rosset, Stéphane Ruais, Astrid Sapritch, Françoise Sélezneff, Julian Taylor.

Thanks also to Galerie 26 in Paris, Galerie en Ré at Bois-Colombes, Galerie du Château in Auray and Galerie Montador in Dieppe for giving us information and lending us photographic documents.

Pages 10-11, 25 and 26: photos D. Fontanarosa. Page 14: photo P.Langevin. Pages 18 and 46: photos D. L'Hostis. Page 19: photo D.Jacobson. Page 21: photo R. Lomprez. Page 26: photos C. Girard. Pages 28, 32 and 43: photos D. Courté. Pages 33 and 95: photos Atelier 80-Françoise Michon. Page 40: photo B. Guédon.

First published in the UK in 2008 by
New Holland Publishers (UK) Ltd
London · Cape Town · Sydney · Auckland

Garfield House, 86–88 Edgware Road, London W2 2EA
www.newhollandpublishers.com

80 McKenzie Street, Cape Town, 8001, South Africa

Unit 1, 66 Gibbes Street, Chatswood, NSW 2067, Australia

218 Lake Road, Northcote, Auckland, New Zealand

© Copyright in this edition 2008 by New Holland Publishers (UK) Ltd

Original title of the book in French: Peindre les Marines
© 2006 Groupe Fleurus – Paris
Published by Groupe Fleurus, Paris, France.

ISBN 978 1 84773 071 8

10 9 8 7 6 5 4 3 2 1

For Fleurus
Editorial Director: Christophe Savouré
Editor: Guillaume Pô
Art directors: Laurent Quellet, Catherine Enault
Production: Aurélie Lacombe
Graphic design and production: Stéphanie Boulay

For New Holland Publishers
Editor: Amy Corbett
Translator: Barbara Beeby
Editorial Direction: Rosemary Wilkinson

Françoise Coffrant

MARINE PAINTING

PHOTOGRAPHS BY JÉRÔME DA CUNHA

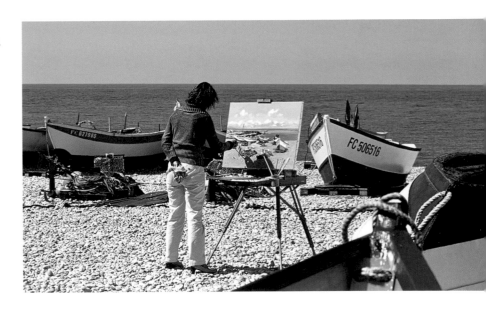

NH

NEW
HOLLAND

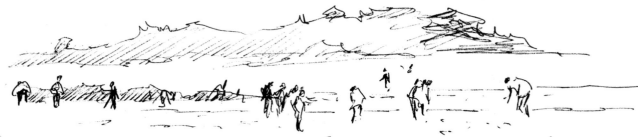

Contents

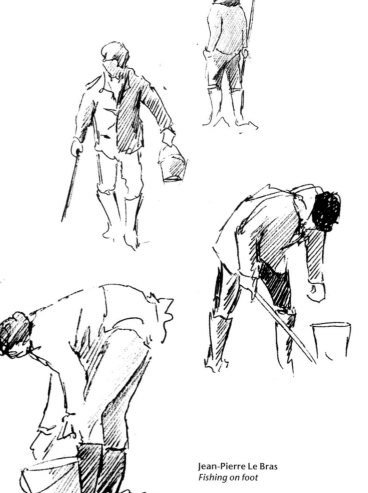

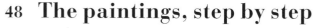

Jean-Pierre Le Bras
Fishing on foot

Annie Puybareau, *Going fishing*, 30 x 60 cm (12 x 24 in). © Adagp, Paris, 2006.

86 Gallery

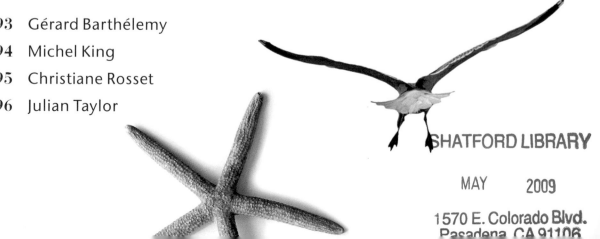

Marine Art

The sea has always inspired men to dream. As far back as prehistoric times, artists etched images on the walls of caves, representing the mysteries of the sea. Great civilisations decorated the bas reliefs of Sumer and Babylon, the temples of Egypt and the palaces of Crete with naval frescoes. Archaeological discoveries have revealed the importance of marine motifs in the art of Ancient Greece, the Roman Empire, Persia and Phoenicia. Their vases, mosaics and murals were decorated with scenes depicting voyages, commerce and war.

For fourteen centuries after the birth of Christ, western art was almost entirely devoted to religion. The sea and boats appeared only in themes inspired by the Bible. One of only a few rare secular examples is the Bayeux Tapestry (1075), a long tableau rich in marine motifs representing the Norman fleet and naval battle scenes.

During the Renaissance a taste for nature and beauty developed. This was expressed in painting by the introduction of the landscape as a backdrop. Very soon the maritime city of Venice became the preferred setting for artists. Carpaccio (c.1450–1525) used the city of the Doges as the theme for his real-life marine scenes and in the early part of the 16th century Venetian painters introduced the sea and boats into their works with increasing frequency.

Holland was a great country of navigators. The 17th century war against Spain was celebrated by the many Dutch painters who recorded heroic deeds on the high seas. Jan Van de Capelle (1624–1679) sought to capture the picturesque hustle and bustle of river navigation; Jan Van Goyen (1596–1656) painted the sky and the water in subtle tones, gradually reducing them to monochrome; for the Van de Velde and Willem families, marine painting was a specialization which they put to use in the service of kings. The success of these themes went hand in hand with the development of landscape painting. Albert Cuyp (1620–1670) and Salomon van Ruysdael (1600–1670) were equally at ease in both genres.

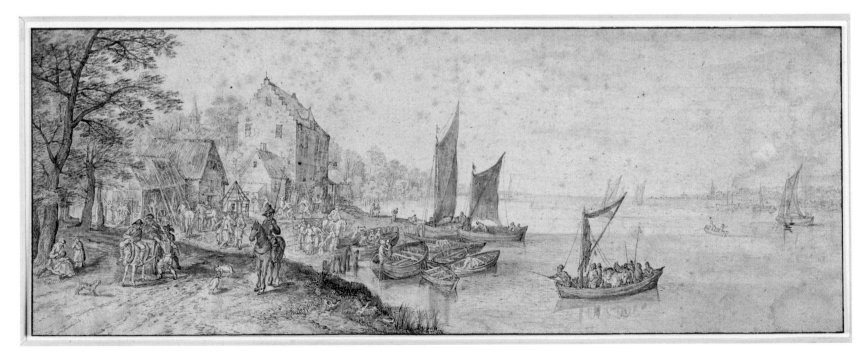

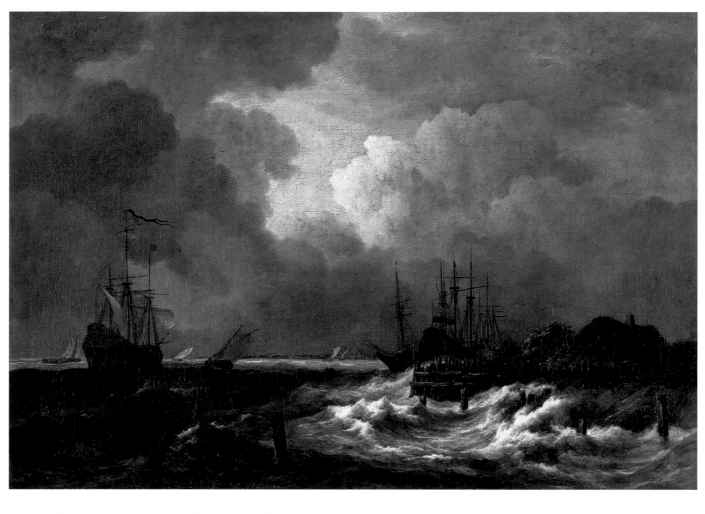

Right:
Jacob Van Ruisdael
(1628/29–1682),
The Storm, c. 1660.
Oil on canvas, 110 x 160 cm
(43½ x 65 in).
Louvre Museum, Paris.
© Photo RMN – Gérard Blot.

Left:
Brueghel de Velours
(1568–1625),
Marine landscape
Ink and wash on paper,
11.5 x 30.7 cm (4½ x 12 in).
Louvre Museum, Paris.
© Photo RMN – Thierry Le Mage.

In the early 17th century the painters from the North settled in Rome where they concentrated their efforts on representing nature, paying particular attention to light and atmosphere. The harbour views of Claude Gellée (1600–1682) – known as Le Lorrain – enjoyed great success. In Venice a new genre was born – 'veduta' (view) – of which Canaletto (1697–1768) is the best known proponent. Architecture was thrown into relief by skilful chiaroscuro and panoramas were enhanced by effects of perspective. Canaletto had

many followers, one of whom was Antonio Guardi (1712–1793) in the early part of his career. In France, Joseph Vernet (1714–1789) painted in the classical tradition of Le Lorrain. He studied the raging elements tied to a ship's mast to capture the effects more successfully and was the first artist to be honoured with the prestigious title of 'Painter to the King's Navy'.

20th century Romanticism gave artists the freedom to express their individualism. Their paintings were

inspired by the emotions that nature aroused in them. The French became familiar with the use of watercolours, pioneered by the English, through the work of the Fielding brothers whom Paul Huet (1803–1869) often visited. Bonington studied watercolours with Louis Francia, struck up a friendship with Huet and went to Normandy where he worked from nature. In 1823 he went back to England accompanied by Delacroix, Eugène Isabey (1803–1886) and Paul Huet. Jean-Baptiste-Henri

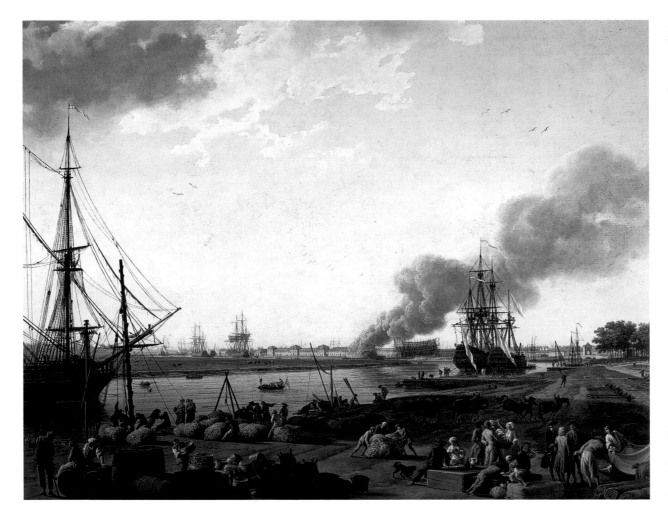

Durant-Brager (1814–1879) painted twenty-one scenes of the Crimean War for the Versailles history galleries established under Louis-Philippe. Pierre Gilbert (1783–1860) specialized in naval battles and Théodore Gudin (1802–1880) took part in the 1837 Algiers expedition. These artists were members of expeditionary forces and were the first Official Painters to the Navy. Along with works depicting violent scenes they produced more intimate marine paintings, expressions of the feelings that nature aroused in them. The coasts of the Channel were favoured by many painters, but particularly by Isabey, Huet and Charles Mozin (1806–1862).

Seascape painters grew rapidly in number from the middle of the 19th century. In Le Havre, Eugène Boudin (1824–1898) captured the transparency of the atmosphere, the soft nuances of the light and the rippling of the sea perfectly. In 1859 he was visited by Baudelaire, Courbet and Jongkind, who was a great influence on him. Claude Monet (1840–1926) was encouraged to work on the theme by Boudin and in 1872 he painted *Impression, sunrise*, a work which was to give its name to the Impressionist movement. Renoir, Sisley, Bazille and Pissarro all belonged to the movement, which gave new life to painting. Their fascination with light drew Manet, Cézanne, Ziem, Van Gogh and Bonnard to the sea coasts, and later, Signac, Dufy,

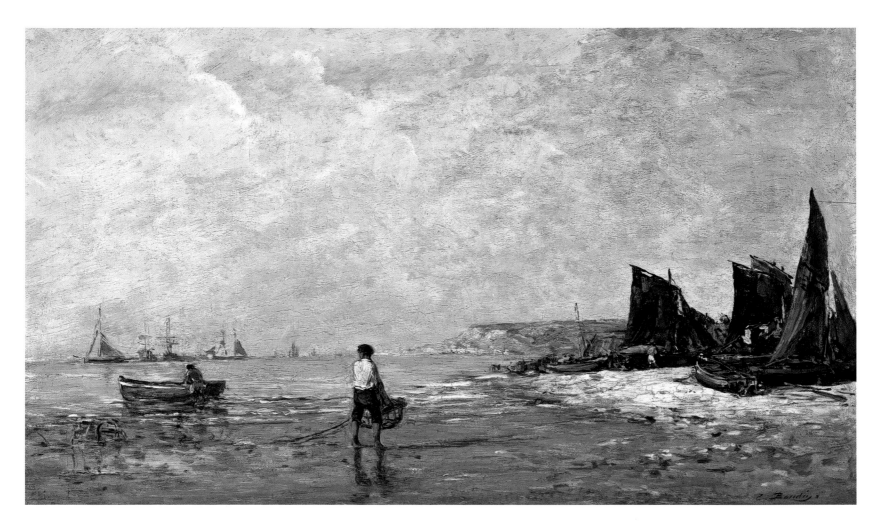

Friez, Marquet and many others. The guild of Official Painters to the Navy, created in 1830, gradually increased in size. The painters Delpy, Marin-Marie, Chapelet and Brenet joined its ranks in the 1930s and soon the new French school of maritime painting became famous. It now numbers forty or so artists, appointed by decree. On ships or in military ports they record scenes of life on board, of landscapes and peoples encountered on the seas of the world. Their signature is followed by an anchor, the distinctive emblem of their appointment. As members of the French Navy, the permanent title-holders hold the rank of lieutenant commander, and those with temporary titles that of lieutenant. They receive no special treatment or promise of any official commission. Every two years they are obliged to exhibit their works at the Salon de la Marine in Paris. With great flair and independence of style, the Navy painters continue a tradition which has made seascapes a major art form. Other artists too are fascinated by the sea. With a special gift for observation, a painstaking technique and a rare sensitivity for the poetry of nature, they demonstrate the joy of painting through their striking, often moving works. The evidence of this lies in these pages.

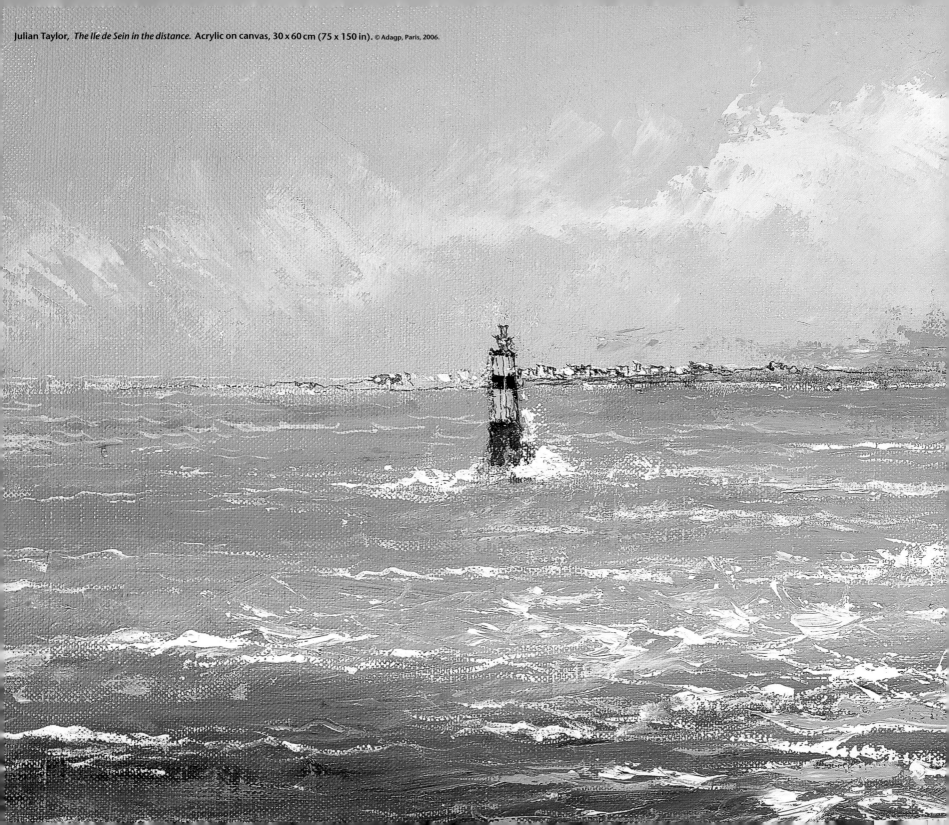

Julian Taylor, *The Ile de Sein in the distance.* Acrylic on canvas, 30 x 60 cm (75 x 150 in). © Adagp, Paris, 2006.

Painting
seascapes ...

Sky

To paint the sky is to paint light, understanding and capturing its essence to recreate it more successfully. The sky determines the atmosphere of a picture, even when it takes up only a small area. Under an azure blue sky the landscape takes on bright, clear colours; under a cloudy, heavy sky shapes are softer and contrasts less distinct.

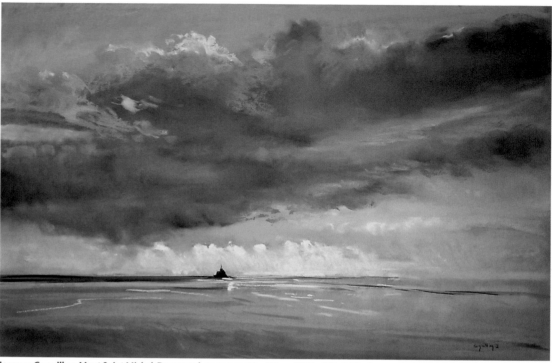

Jacques Coquillay, *Mont Saint Michel*. Dry pastel on paper, 60 x 92 cm (23½ x 36 in). The heavy clouds accent the perspective.
© Adagp, Paris, 2006.

Moving clouds

When you work outdoors you will find that the sky is always changing, particularly near the sea. The clouds are constantly moving and there are times when the sun suddenly disappears, only to flood the sky again a moment later. You must therefore stay focused, and keep in mind the atmosphere you wish to give to the picture. When the wind blows and carries the clouds along at a great pace, it is impossible to reproduce their journey precisely. Analyse the shapes and colours of the clouds and apply light, dynamic touches of colour. Scumbling will help the cloud mass blend into the atmosphere naturally, smoothly and harmoniously.

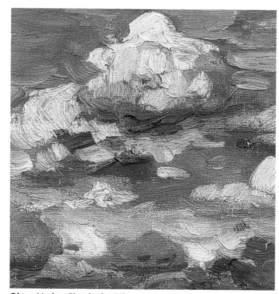

Oktav Votka, *Cloudy sky*. Oil on canvas.

TIP

Clouds are not objects. There is no point in representing them in too much detail, emphasizing their every contour. Nevertheless, their form will give the scene its individuality.

Clear skies

A clear sky appears to have more colour and be more luminous overhead than on the horizon. This is particularly noticeable above the sea where the atmosphere is transparent high above and becomes hazy in the distance. A flat, uniform tone will not, therefore, create this effect of distance. To enhance the deep blue of the sky in the upper part of the painting, enrich the tone with a touch of warm colour, then reduce it gradually. On the horizon the sky will be pearl grey, or even pale yellow.

A clear sky will not look empty if you liven it up with a few different touches. Avoid using regular, flat tones, as it will create a monotonous effect. Also, do not apply strokes horizontally as they will draw the eye to the edge of the composition. With oils use a dynamic touch, which makes the light vibrate. Colour develops a texture when it is applied in all directions. With watercolours, blend the colours. With pastels, go for depth of material and apply several layers.

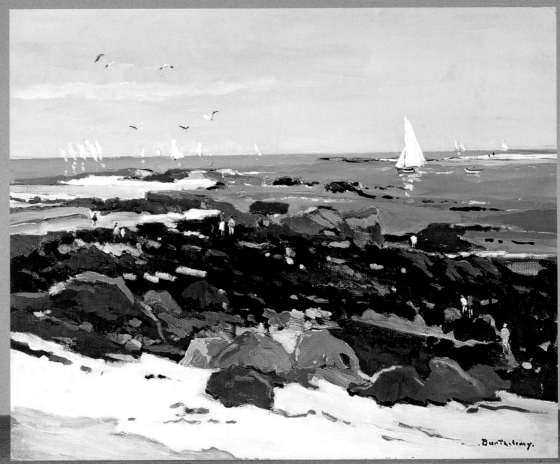

Gérard Barthelemy,
Quiberon.
Oil on canvas, 65 x 92 cm
(25½ x 36 in).

15

Cloudy skies

White, wispy streaks of cloud in a blue sky are a sign of beautiful weather and summer warmth. Light strands of cirrus cloud, propelled by a soft breeze, move across the upper reaches of the sky. The painter captures their shapes and places them in the composition.

Oil paint applied in the open air can convey the wispy cirrus wonderfully well. White clouds can be incorporated harmoniously into a blue sky using a badger-hair brush and the scumbling technique, and will not look as though they are stuck on.

With watercolours work 'wet into wet'. Draw the colours into each other here and there with a grey squirrel-hair brush to suggest the movement of the clouds.

Above:
Stéphane Ruais,
'Coast of legends', Kerlouan.
Oil on canvas, 100 x 65 cm
(39½ x 25½ in). The vivid
greys of the clouds give
the scene its dramatic
character.

Opposite:
Pascal Langevin,
*Palaces in the sky at Belle-Ile
en Mer.* Dry pastel on paper,
49 x 69 cm (19½ x 27 in).
Light streams down onto
the sea through the broken
clouds.

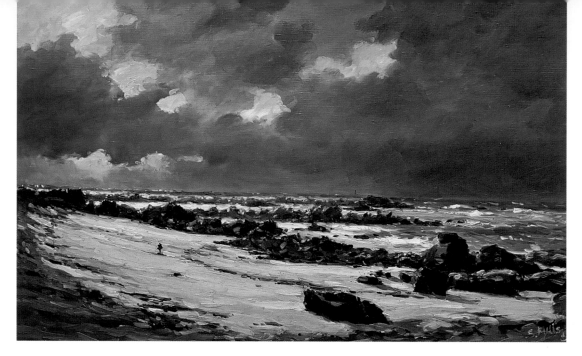

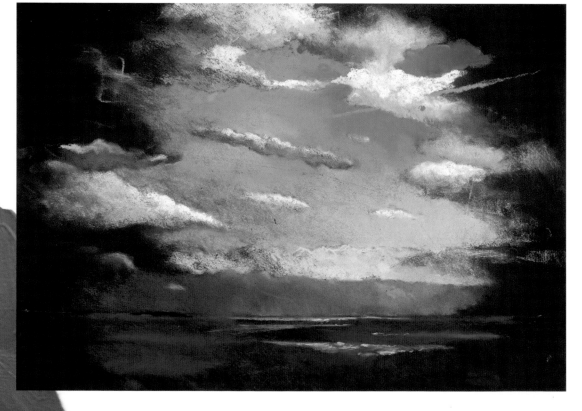

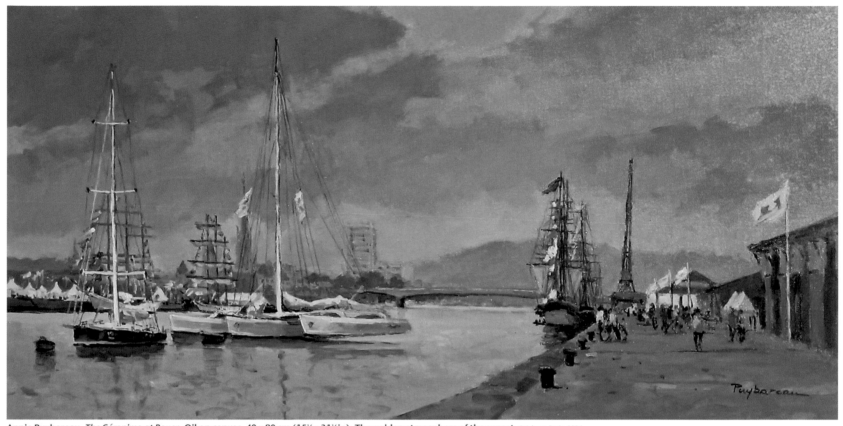

Annie Puybareau, *The Géronimo at Rouen*. Oil on canvas, 40 x 80 cm (15½ x 31½ in). The golden atmosphere of the sunset. © Adagp, Paris, 2006.

Sunsets

At the end of the day the sun sets the clouds and sky ablaze. While this is a very tempting subject for a painter, it requires no less care and attention. It is easy to make the mistake of using too many pinks, oranges and reds. The best effects will be achieved by putting warm tones (natural sienna, cadmium orange, etc) into the blues, greys and purples of the dark sky. Be careful not to overdo it!

Andreï Merdrev, *Distant sails*. Oil on canvas, 38 x 55 cm (15 x 21½ in).

Sea

Painting water is like capturing that which can never be caught. The sea, a vast body of moving water, is characterized by transient colours and light. It reflects the sky and the shore, it carries hopes and dreams, it inspires the artist's imagination as he tries to harness its unpredictable moods.

The colour of water

The ocean is pure movement. At high tide the swell is dark blue, verging on black. On the shore brown and green waves provide a spectacular sight, crashing down on rocks in bursts of iridescent foam or gently caressing the beach. The sea is flat under the midday sun, sparkling with silver light, enriched with turquoise reflections. In the warmth of the evening it turns yellow or even red. Seas everywhere, calm or angry, undergo colour changes linked to the influences of deep currents and of weather conditions governed by the sky, across which the clouds and winds travel.

The palette contains the same blues for the sea as for the sky, but they are generally more intense – cobalt, ultramarine, indigo. It also contains some white, a little crimson or madder lake for the greys, olive green and ochre tints for light reflected on the sand. The horizon, which separates the sky and the sea, is emphasized with a very slightly darker line.

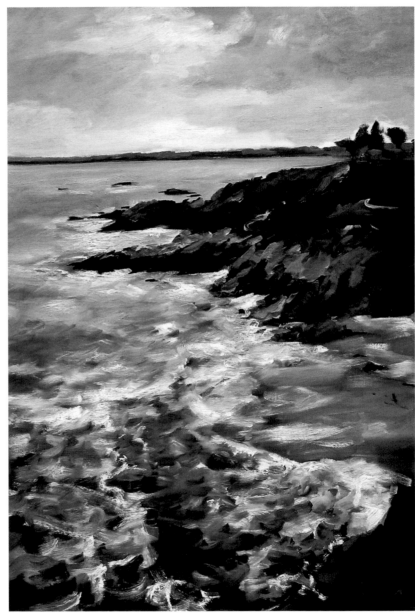

Christoff Debusschere,
Looking towards Brest.
Oil on canvas,
130 x 97 cm (51 x 38 in).
The milky swirl of the surf.

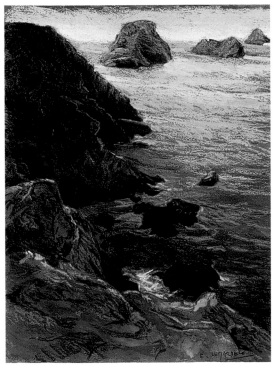

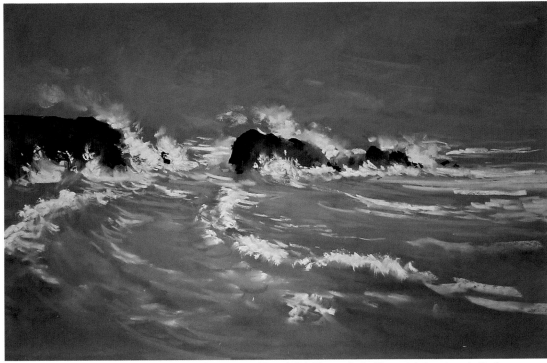

Emmanuel Lemardelé, *The Tas de Pois*.
Dry pastel on paper, 67 x 51 cm (26½ x 20 in).

Jacques Coquillay, *Waves at Belle-Ile*. Pastel on card, 60 x 92 cm (23½ x 36 in). The crushed white pastel gives shape to the foam.
© Adagp, Paris, 2006.

TIP

Do not rinse your brushes in seawater. The salt alters the colours and ruins brushes!

Waves

When viewed from the shore on a calm day the sea is a blanket of waves that approaches from the horizon in gentle, undulating movements. As it gets closer to the shore the trough of a wave is slowed down by the rising sea bed, but the crest continues on its course. The wave breaks and dies away on the shore. As it recedes it meets the crest of the following wave, creating a boiling foam.

Waves contain an infinite variety of colours. They are very dark, almost black, at the bottom and silver blue, turquoise or light green at the top. To convey a sense of movement, brush strokes should be short and applied in different directions. There is no need to spend time on each little wave; it is more a matter of creating the illusion of perpetual movement. Reserve whites and greys, which are iridescent in the sun's reflection, for the crests of the waves. Represent foam by short, sweeping touches of pure white.

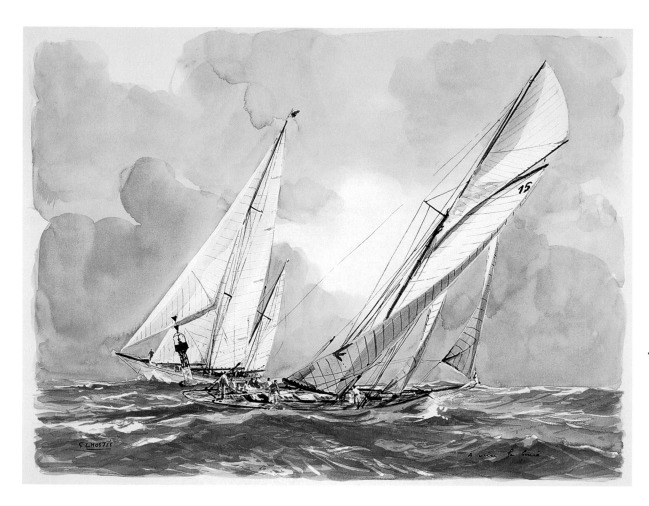

Guy L'Hostis, *"Nan", sailing round the buoy*.
Watercolour on paper, 39 x 29 cm (15½ x 11½ in).
Contrasting shadows of the strong waves.

Open sea

Out on the open sea the swell creates wide, deep waves. A wave is a mass; it must be conveyed as solid matter. Its shape indicates the strength of the wind. From a boat the artist can observe the direction of a wave and evaluate its height. The inside is in shadow, while the wind whips up a light foam on the unfolding crest. The sea will be predominantly blue, violet, green or brown with bright highlights, depending on the light, the time and the surroundings. The impression of movement can be conveyed by the direction of curved brush strokes and by paint enriched with several layers of colour. Dark tones alternated with light ones convey movement on the surface of the water effectively.

To capture the constantly changing shapes and colours of the sea, make felt-tip or watercolour sketches to provide the basis for paintings in the studio. Position the horizon high on the page, fix the direction of the waves with a brush stroke, apply the different colours of the water – cobalt blue, ultramarine blue, cerulean blue mixed with a little magenta for the violet tones of the areas in shadow, turquoise blue, ultramarine light mixed with a touch of yellow when the sea is greener. Your brush lines must always follow the direction of the current.

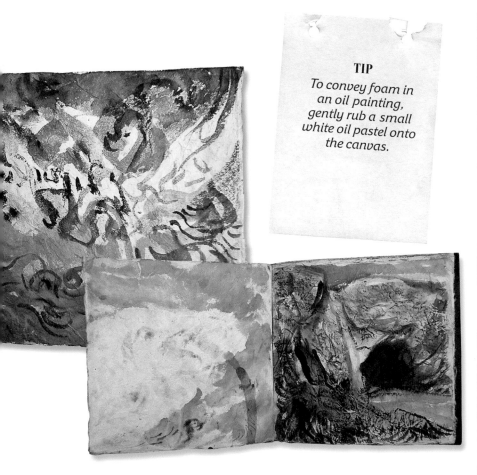

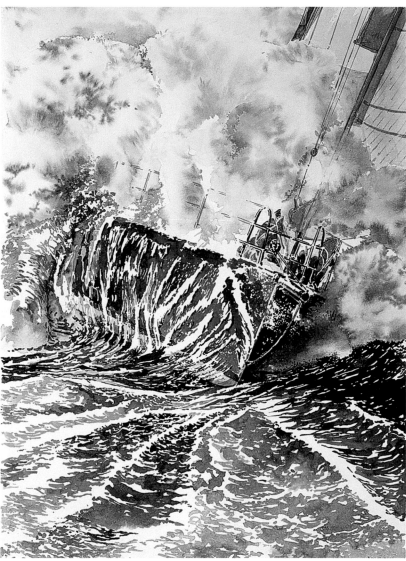

Astrid Sapritch,
sketch books.

Dan Jacobson, *The Blue Stem*.
Watercolour on paper, 95 x 75 cm
(37½ x 29½ in). The art of keeping
areas free of colour!
© Adagp, Paris, 2006.

Foam

Foam is created when sea water is churned up. A wave rises and breaks in a bubbling turmoil of white foam. Viewed from the shore waves always approach horizontally, parallel to the beach, sometimes in long rollers. In contrast, the showers of foam at the stem of a sailing boat or in its wake have a direction of their own and seem to spring out of the boat's hull.

The impression of foam can be achieved with oils or acrylics using a hard brush and thick paint. Work in the open air. Apply white paint in light dabs on a neutral background. With water colours the best result comes from keeping areas of white paper free of colour. If you do not want to use masking fluid, brush a little white gouache forward with an old toothbrush or gently scratch the medium with glass paper. To achieve a mistier effect, spray clean water on the contours with an atomizer.

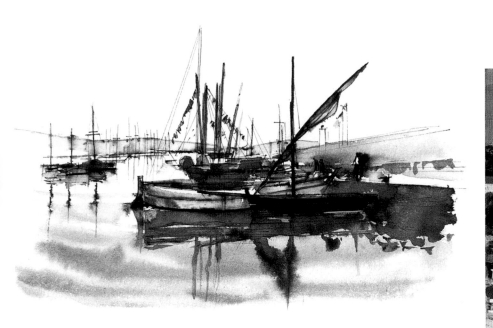

Reflections

How do you capture the ever-changing effect of sunlight sparkling on water? When the sky is reflected in the sea the blue or grey tones are the same but their value is different, as the water is always a little darker. With oils, the brush strokes follow the direction of the waves whose crests, in fine weather, look silver. In the shelter of harbour walls, water gives an inverted, perpendicular and symmetrical image of boats moored at the quayside. When the wind ruffles the surface, the image breaks up and undulates with the ripples. The broken reflection of an object is more elongated than its reflection when still. Reflections of a light-coloured mass in the water have the same tones but are darker. Conversely, dark shapes look slightly lighter. Reflections follow the same laws of perspective as the objects they reflect. An object which forms an angle with its support is reflected at the same angle. The reflection of a vertical object will be an extension of the object itself. An object which leans towards the painter creates an elongated reflection which also leans towards the observer.

Above:
Michel King, *Study.*
Wash on paper.
© Adagp, Paris, 2006.

Opposite:
Jean-Pierre Le Bras,
The Harbour at Perros-Guirec.
Oil on canvas, 73 x 54 cm
(28½ x 21½ in).

TIP
Reflections are the inverted image of the subject you are painting. They are the same distance from the surface as the subject, so their proportions are the same.

Different seas

In some latitudes the sea contains unexpected colours which can take the painter by surprise. The Mediterranean is constantly changing colour. It is dominated by intense blues – cobalt, ultramarine, cerulean blue, turquoise – with green or violet tones. A golden sunrise suffuses the sky and the sea with orangey-yellow light. In the heat of high summer backgrounds merge together in a hazy atmosphere of milky grey mixed with a touch of yellow or orange. In winter the horizon stands out sharply against the clear sky.

Christiane Rosset,
Stopover at the île Saint-Paul.
Oil on canvas, 92 x 73 cm (36 x 28½ in). The rain is suggested by a few slanting strokes.
© Adagp, Paris, 2006.

Christiane Rosset,
Arrival of the Royale at Crozet.
**Felt drawing,
21 x 30 cm (8½ x 12 in).**
© Adagp, Paris, 2006.

In the tropics, the colour of the sea is affected by evaporation which is caused by the heat and leads to the formation of thick, stormy clouds. In calm weather the still water is often turquoise, taking on the green of the sandy depths and the coral rocky masses. The purity of the atmosphere makes it cristalline and transparent.

The cold seas of the southern or northern regions look frozen. The tones are pale, washed-out, even white. In good weather the shadows on the glaciers become blue and are reflected in the sea, which takes on cobalt, turquoise and cool blue tones. The aurora borealis presents a blend of colours (pink, green, violet) of rare beauty, but which are always difficult to paint.

Coasts

Beaches provide a multitude of colours, whether they are covered in sand or shingle. The variety of shades of grey is determined by the nature of the shoreline – white limestone, grey flint, pink granite, black shale. The season (summer or winter), the light (morning or evening) and the tide also change its appearance. The monotony of long stretches of sand is broken by the colourful mass and undulating lines of rocks. From all these different aspects you must choose the one that you feel conveys the character of the place most faithfully.

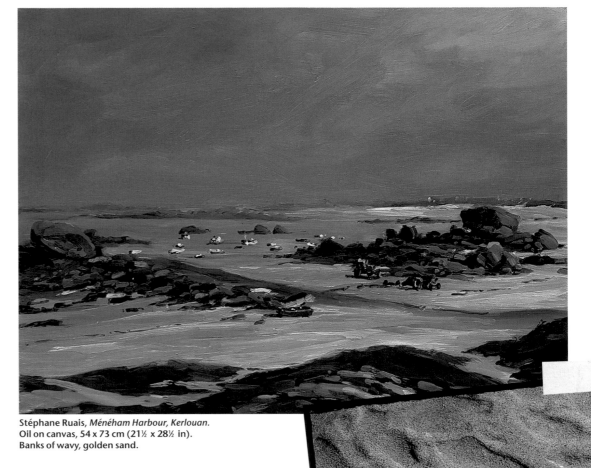

Stéphane Ruais, *Ménéham Harbour, Kerlouan*.
Oil on canvas, 54 x 73 cm (21½ x 28½ in).
Banks of wavy, golden sand.

Beaches

A broad perspective composition is necessary to convey the effect of the vastness of a beach, whereas an almost vertical view of a shore washed by waves will appear to have great depth due to the effect of perspective. Choose a time of day that gives contrasting colours. Treat the texture of the sand as simply as possible. Start by marking the areas of light and shade created by uneven surfaces, pockets of water, the shape of a dune or the presence of a rock. Then superimpose thin transparent colours in long horizontal strokes or flat areas of colour. Use cool tones (blue, green, violet) in the shadowy areas and warm tones (yellow, orange, red) in the areas of light. Create some contrast with a few clouds in the sky.

High and low tide

The tide governs the comings and goings of fishing boats and pleasure boats along the Atlantic and Channel coasts. It is at its fullest at the time of the equinox. At low tide, several hundreds of metres of strand are revealed in some places. Wet sand reflects the sky; shingle and rocks covered in seaweed punctuate the landscape with intermittent, muted hints of colour.

First look for a good composition. The sea in the distance may be just a line on the horizon, high up in the composition. A small boat drawn up on the shingle will give scale to the scene. The fishermen's colourful oilskins will brighten up a stretch of brown sand.

At high tide the sea takes on cobalt blue, emerald green and turquoise tones. As it breaks on the rocks it sends up vivid white spray. The glistening rocks are ivory black, brown or red; the vegetation is bladder green, umber or yellow ochre. These contrasting colours create a dramatic scene.

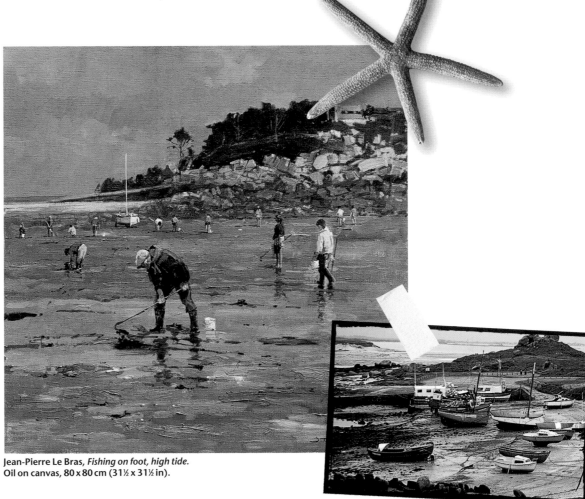

Jean-Pierre Le Bras, *Fishing on foot, high tide.*
Oil on canvas, 80 x 80 cm (31½ x 31½ in).

The 'Fishermen's dock'
in Kernic Bay (Finistère)

Gérard Barthélemy, *Bandol.* Oil on canvas, 38 x 55 cm (15¼ x 22 in).

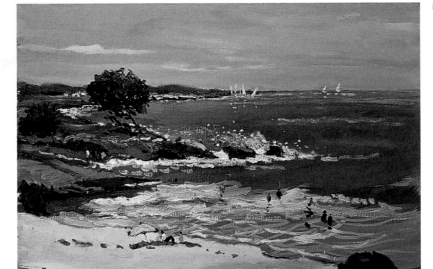

23

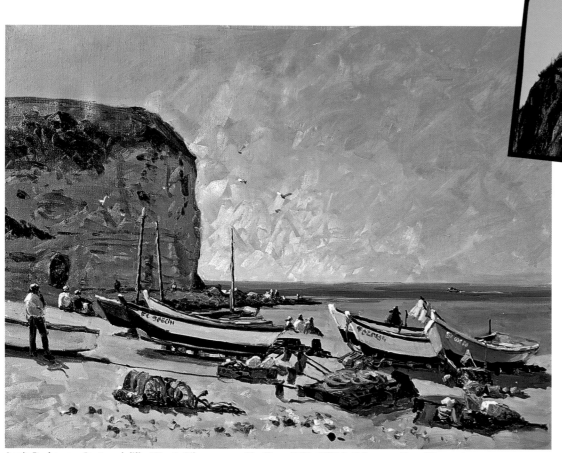

Annie Puybareau, *Boats and cliffs at Yport.* Oil on canvas, 50 x 65 cm (19½ x 25½ in). **Colours on the white sand.** © Adagp, Paris, 2006.

Cliffs and rocks

Cliffs and rocks dropping sheer into the sea provide spectacular subjects. Look for a scene where the coastline is shown to advantage overhanging the sea, creating an inlet. To convey the mass and density of rocks, the contrast between the rock face which is in the shade and the surface which is exposed to full light must be emphasized. Look carefully at the structure of the rocks. Some are rounded by erosion, others are fragmented and have sharp points. Note the direction and the path of the sun. Begin by applying large areas of colour,

working with wide strokes or flat washes of thin paint. Then show the details with short, thicker strokes. Do not modify the areas of light and shade any further in case you upset the balance of the structure. Work the rounded forms in shaded tones, blending the contours of the different planes. Bring out the edges with coloured impasto applied with a knife. Emphasize the crevices with dark lines. To give the effect of perspective, make the foreground denser than the background.

TIP

When using watercolours, apply the base colour of each area in light-coloured thin wash. Then make the colour more solid using the tip of the brush and very little water. Work dry on dry.

Lighthouses

The imposing architecture of lighthouses rising up out of the sea is an attractive subject for painters. Lighthouses are built on headlands or small rocky islands where access is almost impossible, and are often painted in bright colours so they can be seen from a distance.

A lighthouse in the sea, set in the middle of a canvas, fills the whole space and stands out against the sky right to the top of the painting. Rely on your sketches and photographs to recreate the mass of the rocks and the fullness of the waves.

TIP
To draw a perfectly upright lighthouse, slide a set square along the stretcher from top to bottom, leaning your loaded paintbrush against its edge.

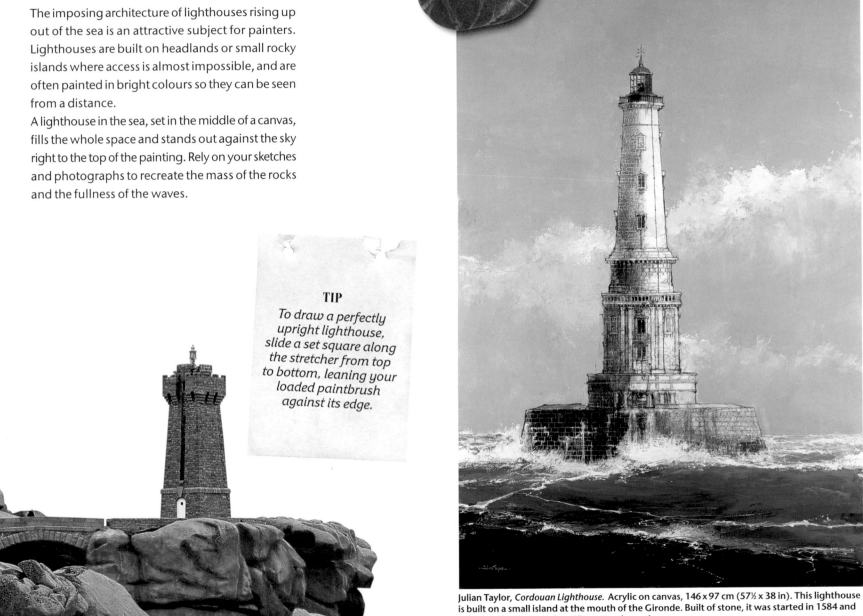

Julian Taylor, *Cordouan Lighthouse.* Acrylic on canvas, 146 x 97 cm (57½ x 38 in). This lighthouse is built on a small island at the mouth of the Gironde. Built of stone, it was started in 1584 and completed in 1610. It rises 63 metres above the sea. © Adagp, Paris, 2006.

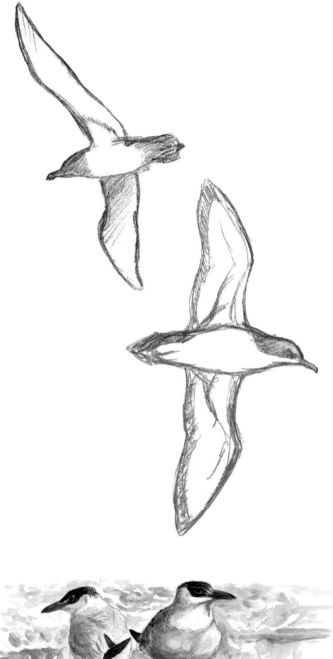

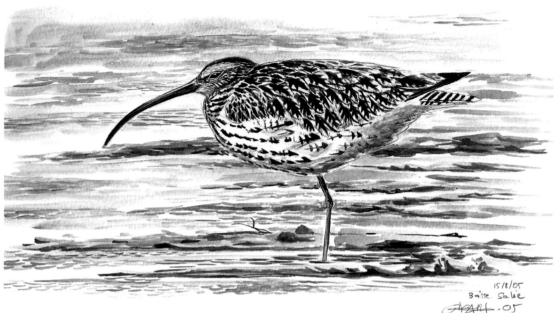

Vegetation

The vegetation found on cliff tops and in the hollows of sand dunes is usually dry and stunted. Whether in the form of short grasses, succulents or thorny plants, it is neutral and subdued in colour, with an ochre, brown or dark green base. Treat it as a mass, from which to pick out one single element – a clump of sea spurge or sand reeds for example. The tufts of vegetation are worn down by the wind; position your strokes of colour to convey the atmosphere of the place. Rocks near water are covered with seaweed in places. Suggest this with a few dabs of very dark, almost black, colour. Make them smaller if necessary, to avoid making the scene too heavy.

Sea birds

The black-headed gull, the herring gull and the grey heron are the most common coastal birds. On the Atlantic coast, look out for migrating cranes and short-billed geese in spring and autumn. In the Camargue, follow the migration of flamingoes and small waders, plovers, woodcocks and oyster catchers dipping their long bills into the mud. Choose a sheltered spot on land. Watch the birds through binoculars. Do not try to capture too many things at once; the composition will come naturally. Do not neglect the surrounding landscape which is essential for the creation of a harmonious scene.

Cyril Girard, *Curlews, puffins and terns.* **Watercolour and pencil on paper.**

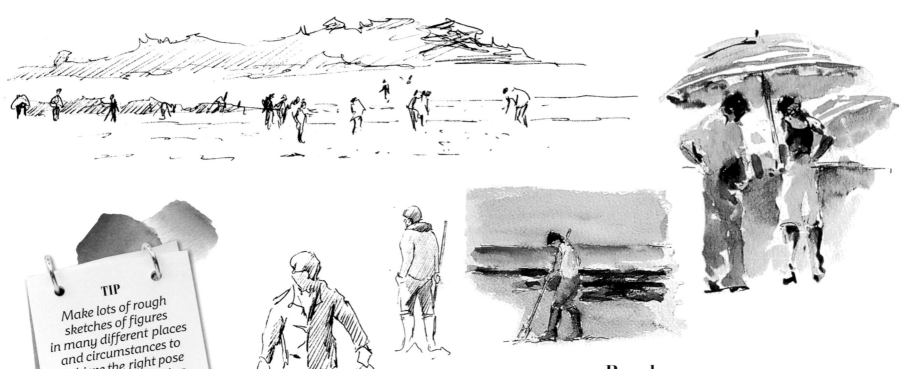

Top right:
Annie Puybareau,
real life sketch.
© Adagp, Paris, 2006.

Above:
Jean-Pierre Le Bras,
Fishing on foot.

People

An empty beach is peaceful and welcoming. Yet on the other hand, cockle pickers, bathers or children building sandcastles bring life and movement to a scene.

Position people in the middle distance or the background if possible, subordinating them to the landscape. Avoid putting them in the middle, where they might appear 'stuck on'. As an aid, draw the figure on a piece of tracing paper and place it on your painting. Move it around until you find the right place for it in the scene. Do not concern yourself with anatomical details; the posture is what counts. To paint figures in the middle distance, begin with a general outline and shape them a bit at a time with touches of light and shade. This is how figures develop substance and balance.

Ports and harbours

Docks, boathouses, dry docks, jetties, harbours, containers, loading wharfs with their cranes, ships of all sizes, winches, tow ropes and ferries are all attractive but complex subjects for painting. It is for you to choose an approach that will convey the lively atmosphere of a busy port or harbour without allowing yourself to be swamped by too much detail.

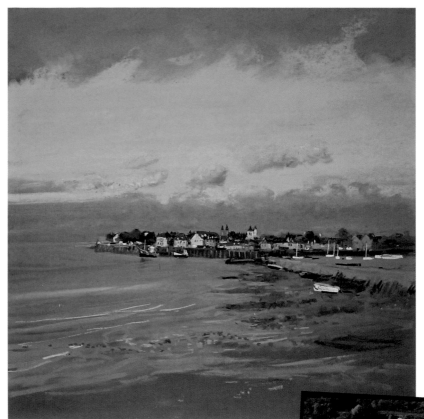

Jacques Coquillay, *The Crotoy*. Pastel on paper, 65 x 65 cm (25½ x 25½ in). © Adagp, Paris, 2006.

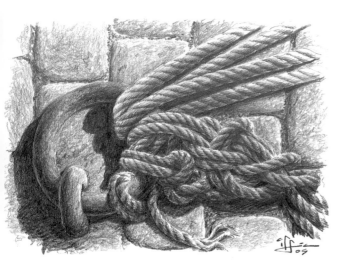

Iffic, *Hawsers and ring*. Graphite on paper, 23 x 32 cm (9 x 12½ in). Contrasting values create relief.

Creeks and rocky inlets

The coast from Marseille to Cassis is lined with wonderful rockly inlets. These deep enclosed valleys, flooded by the sea, cut out chasms in the high limestone walls. They are reached by boat or admired from along the Custom Officers' Route above. The vegetation is luxuriant, the rocks white, the sea an intense blue. Look for a view that shows the contrasting colours, light and shade to best advantage. From a position high above sea level, the horizon may be outside the area of your painting. In this case there will be no sky. Creeks provide shelter for sailing boats. They are an ideal place to study the shape of boats, whether they are moored or in motion.

Marinas

The colourful and lively spectacle of a marina is very attractive for the painter, yet the abundance of detail to be found makes it a difficult subject. Yachts jostling side by side along the landing stage and the masts and flags of sailing boats provide a wealth of detail to choose from. Walk around the quays first, to find a good viewpoint. The atmosphere changes depending on the time and season, so make a number of sketches at different times of the day. Choose a good subject and place less defined forms round it in contrasting colours, lighter or darker, which will set it off. Give consideration to the background – the sea, the coast or even the hills in the distance. They must act as a setting for the subject. Treat the sky and background with thin transparent glacis paint; the far distance will be light and hazy. Use thicker paint for the boats to define their form and mass. Use a small, flat, curved brush which enables you to vary the thickness of the line in one movement.

Jean-Pierre Le Bras,
The Quay at Pont-l'Abbé.
Pencil on paper.

Gérard Barthélemy,
Lalonde Harbour.
Oil on canvas,
33 x 55 cm (13 x 21½ in).

Fishing harbours

When fishing boats return after a day's work, the harbour livens up. Boats come alongside, crates are unloaded, fish are piled up on the quayside or in the market waiting to be auctioned. These are all juicy subjects for a painter. Choose a specific subject – the rowing boats, the silver fish, a boathouse. In a harbour we see the boats from close up; they are foreshortened. Record them in simple geometric form, which will overcome any lack of perspective. Make on the spot sketches, separating out the themes. Group two or three elements together to create a compact composition. Try a few compositions with a stretch of water in which the quay and the boats are reflected. Do not forget the fishermen, those workers of the sea, with their colourful oilskins. They are essential to give a human dimension to your picture. Then set up your easel in a spot which is ideal for painting your chosen subject, and to which you can return the following day to finish, should you need to do so. The activity in a fishing harbour is exactly the same day after day.

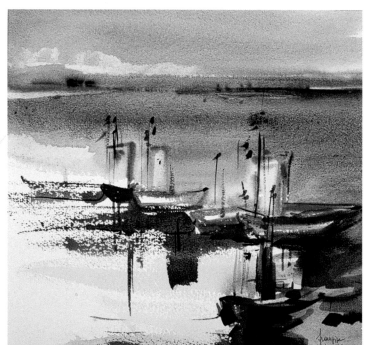

Above:
Annie Puybareau,
A good day's fishing
Oil on canvas, 50 x 61 cm
(19½ x 24 in).
© Adagp, Paris, 2006.

Opposite:
Françoise Sélezneff,
Small fishing boats at Lotivy
Watercolour on paper
38 x 38 cm (15 x 15 in).

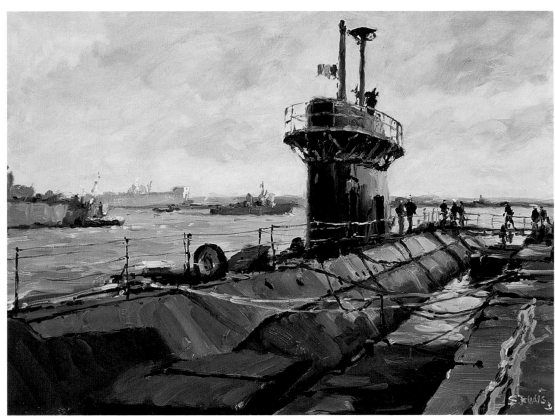

Below:
Christoff Debusschere,
The Quay at the Port of Zeebrugge
Oil on canvas, 100 x 81 cm
(39½ x 32 in).

Right:
Stéphane Ruais,
Submarine Bévéziers at Brest
Oil on canvas, 54 x 73 cm
(21½ x 28½ in).

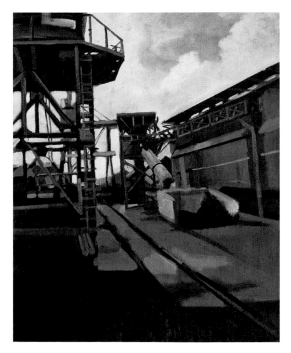

Commercial ports and docks

Commercial ports are open areas giving occasional glimpses of the sea. How you determine the layout of their massive structures will depend on the places where the light breaks through. From a viewpoint that has taken your fancy, look for a balance between the main buildings. Painting the giant beasts of aircraft carriers, cruisers, frigates and submarines in a dockyard remains the privilege of Official Painters to the Navy, unless you have been invited to do so. However, if you do not have permission to go through the gates, you can always look for a point nearby from which to observe the immense warehouses and rows of quays in their entirety. This grey and brown world presents a sober composition. In the background, the distinctive silhouette of a frigate or patrol boat reveals glimpses of the upper decks, a pontoon, the bridge, some radio antennae and radar equipment. Paint what you see without too much detail against a background of sea and sky. The ship will be recognisable even if it is truncated. Work on shadows and highlights in a harmony of cool greys. The silhouette of men moving around will give life to a composition.

Boats

The presence of a boat in a seascape will bring a dynamic element to a sea which may be rather flat, to a beach or to a quayside. It is not necessarily easy to draw a fishing boat pulled up on the sand, a ship slicing through the swell in the open sea or a sailing boat tacking in the trough of a wave. You will need to do many real-life sketches before you can represent the bulk of a boat's hull, the line of a mast, its shrouds or sails.

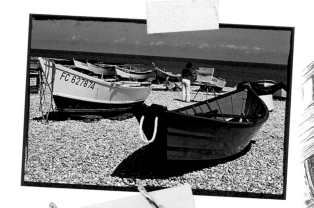

TIP

When you look at a landscape, the horizon is always at eye level. If your viewpoint is above your subject matter, the vanishing point of the lines of the perspective of the object will be on the horizon.

Iffic, *The Maërl at Rostellec*. Graphite.

Small craft

Small boats, modest craft with oars or sails, are not complicated structures to draw. Their lines are pure – straight or curved. Take a look at a small boat on the sand at low tide. Look carefully at its proportions and rounded form. Make some rough sketches from different angles. Build up your drawings by looking for guiding lines and simple geometric shapes. Do not try to represent all the details in or on the craft (rigging, ropes or buoys); choose one or two – the cleats, the tiller or the oars, for example – which will be enough to give the craft its identity. Draw the waterline, which is often emphasized with a line of colour, then mark the shadows under the hull to convey the shape and curves of the boat.

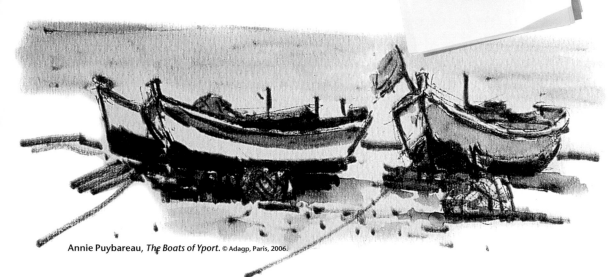

Annie Puybareau, *The Boats of Yport.* © Adagp, Paris, 2006.

Sailing boats

A sailing boat slicing through the waves is an irresistible sight for a painter. Look carefully at how the hull leans as it cuts through a large, turbulent wave. Notice how the boat moves forward on a calm sea; it is upright, surrounded by gentle swell. It should not look as though it is placed on top of the sea, but rather that it is part of the water. Observe the direction and strength of the wind, which determine the position of the sails. Yachts and catamarans are equipped with jibs, spinnakers and large triangular sails depending on their type. On sailing boats such as schooners with three or more masts, there are many sails and their shape varies depending on the mast on which they are hoisted. Choose the parts of the rigging that can be most easily seen from your viewpoint (masts, ropes, shrouds, yards, rudder, helm, anchor). Omit anything that might make your painting cluttered.

TIP

If you are using acrylic paints, do not forget the retarding medium. The sun dries the paint very quickly, as does the wind.

Christiane Rosset,
Tall Ships.
Oil on canvas, 100 x 50 cm
(39½ x 19½ in).
© Adagp, Paris, 2006.

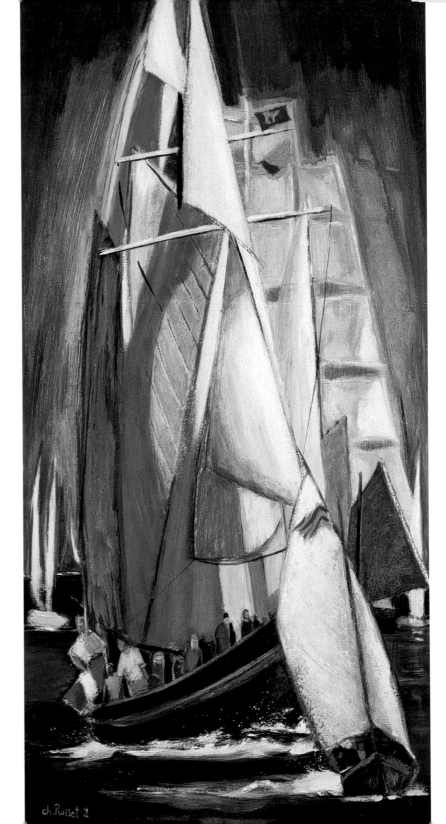

33

Sailing school

Sailing schools use catamarans. Children practise in 'Optimists', small boats that punctuate the beach with splashes of colour. Position yourself well up the beach in a shady spot sheltered from the wind. Observe the position of the boats in relation to the sun. On the water some sails glint in full sunlight, others move into shadow when they change tack. They are reflected, even in shallow water. The 'Optimists', with their trapezium-shaped sails, parade along in single file. For a simple and dynamic layout, place the horizon quite high up and group a few boats together in a geometrical shape in the middle distance. Play on the colours of the sails.

TIP
Canvases on stretchers are often too light to withstand the buffeting of sea breezes. If you are working on location, choose smaller panels of wood or cardboard, so you can finish the painting in one sitting.

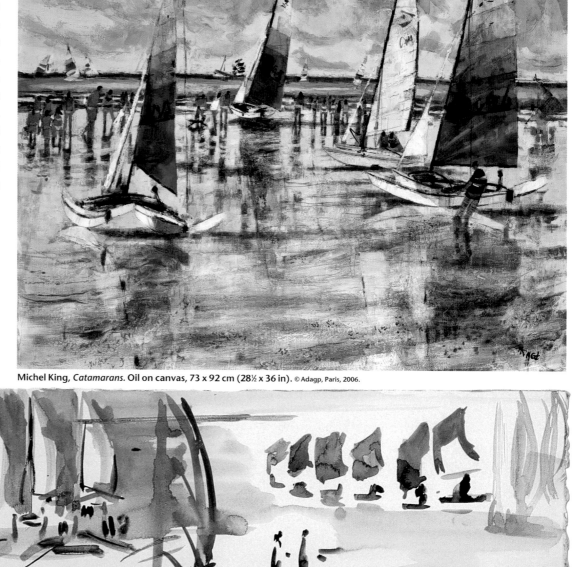

Michel King, *Catamarans.* Oil on canvas, 73 x 92 cm (28½ x 36 in). © Adagp, Paris, 2006.

Françoise Sélezneff, Sketches drawn at the Rohu sailing school on the Quiberon peninsula.

34

Large vessels

Cruise liners, ferries, freighters, trawlers, stately tankers and Navy vessels are just some of the subjects that painters particularly enjoy. To familiarize yourself with the subject, draw some ships in profile, then from a three-quarter angle. You will find that the main difficulty stems from the bulging shape of the vessels, particularly when you see them face on, when they are foreshortened. In a close-up view, put the structural elements – cabins, bridges, turrets etc – in perspective on different planes. Pale colours on dark will give depth. The use of two complementary colours, one immediately on top of the other, will produce the same effect.

Right:
Gérard Barthélemy,
Honfleur.
Oil on canvas,
65 x 50 cm
(25½ x 19½ in).

Opposite:
Christoff
Debusschere,
Two frigates at the Brest dockyard.
Oil on canvas,
120 x 60 cm
(47 x 23½ in).

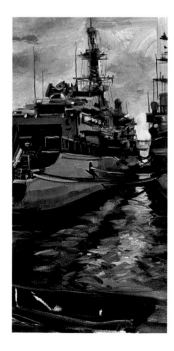

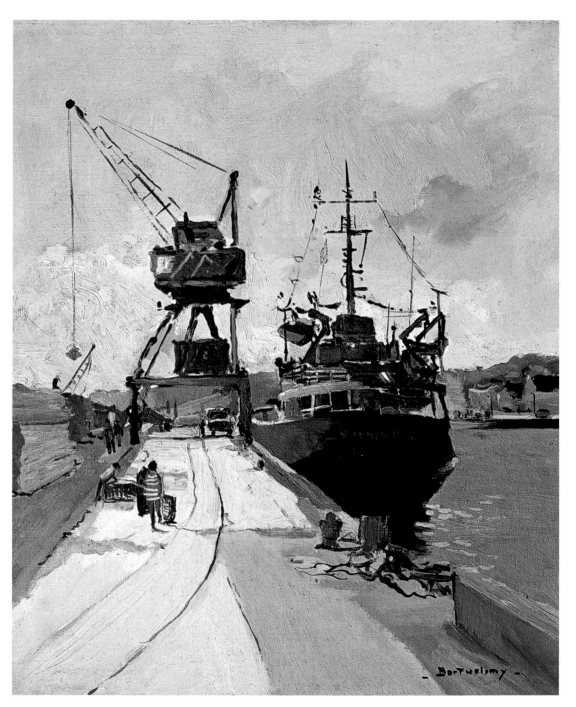

Composing a seascape

A seascape is a special kind of landscape. The movement of the water and the clouds in the sky creates fleeting images in a changing light. Faced with such a stunning sight, the artist must compare, choose and eliminate in order to compose a harmonious work of art. Observing some simple rules will help you to free up your creative imagination.

TIP
Prime your canvases in the studio with a layer of acrylic resin. Take with you a warm colour (sienna or ochre) and a cool colour (blue or Payne's grey). Once you are at your location you can choose the one that is most suitable, depending on the weather conditions.

Jacques Coquillay's box of pastels has folding legs and a lid that doubles up as the easel.

Above right:
Gérard Barthélemy at work.

Equipment

An artist's equipment must be light and easy to transport. Choose two or three spiral-bound notebooks which are not too bulky and a folding outdoor easel with a horizontal support. If there is a breeze, do not use anything larger than royal format (50 x 65 cm) or paint on pads of paper. Take a box with eight to twelve pots of watercolour and a small notebook to make a note of the colours. The folding box-easel for oil painting comprises a storage compartment and a wooden palette. The canvas can be attached to it, so it can be transported while still wet. It can also be used for painting with acrylics or gouache. It holds large and small brushes, a palette knife, bottles of medium, coloured pencils, charcoal, an eraser and a cloth. The thinners and turpentine are stored separately. Prepare canvases on different stretcher formats in the studio.

Sketches by
Françoise Sélezneff.

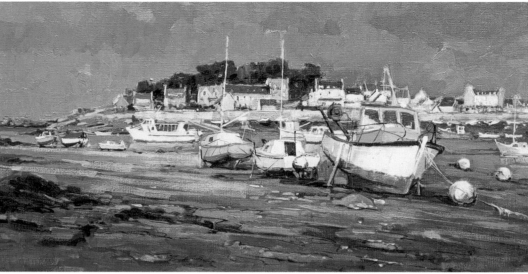

Jean-Pierre Le Bras, *Low tide at Ploumanac'h*
Oil on canvas, 50 x 100 cm (19½ x 39½ in). The rounded shape
of the hull shows clearly at low tide.

Getting set up

Check the weather forecast before you start on your painting. In sunny conditions take a hat and a large white adjustable nylon sunshade that you can attach to your easel. On a bright day avoid wearing white clothes – they might reflect on the canvas or the paper. If you want to paint sitting down choose a stool with three tubular steel legs and a leather seat. Avoid folding canvas beach stools – they are not stable enough to work on for a long time.

If the place you have chosen is windy, find a sheltered spot near a rock or a building. Push your easel well down into the sand to secure it and wedge it with large pebbles. Light rain from a cloud passing overhead will not affect an oil painting at all, but a single drop on a watercolour painting is disastrous, so be careful!

Stormy weather stirs up the sea and creates a spectacle of changing colours which you may find inspiring. Find a sheltered spot – behind your car with an old cloth spread out, for example – and work with oils on a small board.

When you paint on location, you have to work in uncertain weather conditions – or find a charitable soul who will hold the umbrella!

TIP
If the wind rises, hang a heavy stone on a piece of string from the easel to stabilize it.

Choice of subject

When you work outdoors a considerable range of subjects is available to you. As far as possible try to avoid over-familiar scenes and tourist spots that have been painted a thousand times before. Instead choose a more original viewpoint that expresses your own individuality. Try to confine yourself to one specific subject – for example, a fishing harbour at low tide with cliffs on the horizon. Indeed, you should be wary of panoramic scenes too rich in detail; they may end up looking like a jumble of objects in which nothing particular stands out. Do not be afraid to exclude a detail or to take a few liberties with reality. No-one will blame you for leaving out a badly parked car, a rusty street lamp on the edge of the beach or a decrepit old building! Similarly, if you think it helpful you can add a few things taken from elsewhere – a fishing boat, flags on a mast, a few trees in the distance, etc. The painting must be an expression of your response to the scene; to choose a subject well, above all else you must love it.

TIP

If you have a digital camera, take photos of your subject from different angles. It will help you to find the best viewpoint.

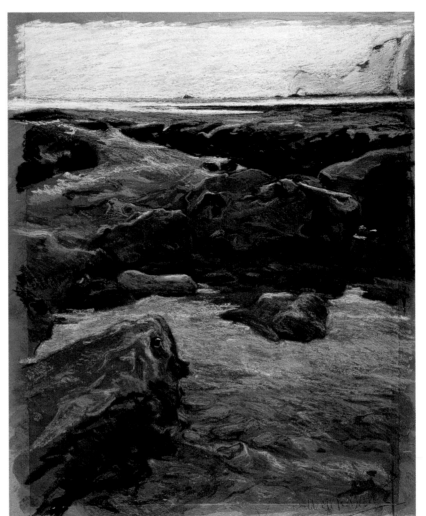

Emmanuel Lemardelé, *Étretat*.
Dry pastel on card, 75 x 55 cm (29½ x 21½ in). Earth colours for this wild coast.

The angle of view

When it is time to start constructing your work, it is absolutely essential to choose a good angle of view. Avoid enclosing the backdrop between two equally important elements (rocks or boats, for example) as they may prevent the eye from properly entering into the picture. A few details may also be useful to define the scale of the picture (some vegetation on a river bank, a lighthouse, etc) and at the same time highlight the splendour of the subject matter. Do not hesitate to use different angles of view as many times as is necessary (they will vary depending on whether you are standing up, sitting down or at ground level) to find the right position. Try to distinguish the centre of interest in the painting clearly; it will establish the structure of the painting and will be the point of convergence of the construction lines on which the arrangement of the scene is based. These lines will be reinforced by the interplay of shadow and light, volumes and colour. If the frame is changed from a horizontal to a vertical format the composition, which is now based on new construction lines, will take on a very different aspect.

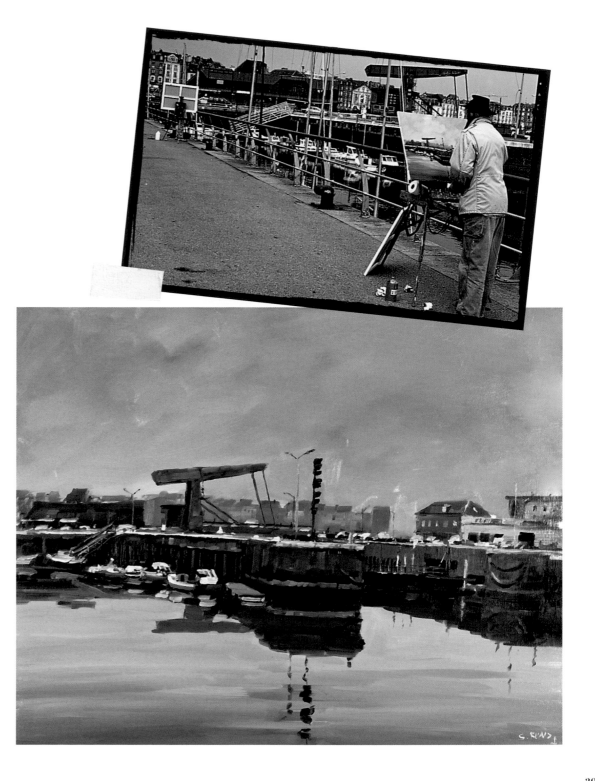
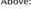

Above:
In Dieppe harbour two painters stand facing each other – Stéphane Ruais and at the other end of the quay, Christoff Debusschere, whose work is presented, stage by stage, from page 74. They are clear proof that the same subject can be interpreted from two diametrically opposite points of view!

Opposite:
Stéphane Ruais, *The Port of Dieppe, the Lock.*
Oil on canvas, 60 x 73 cm (23½ x 28½ in).

Bernard Guédon, *Herring Gull at Raz Point*. Oil on board, 20 x 40 cm (8 x 5½ in). A very elongated format for this contemplative gull.

Format

Stretchers for canvas are classified in three categories – figure, landscape and seascape. Naturally the seascape format – the most elongated – is the most suitable for our subject matter. However, there is no reason why a squarer format cannot be used. Stretchers are identified by a number, which groups them according to dimension.

In order to make the best choice of format and to define the space required for your work, you can make a viewfinder with two L-shaped pieces of card.

Table of different formats (in cm)		
Number F – Figure	L – Landscape	S – Seascape
0 18 x 14	18 x 12	18 x 10
1 22 x 16	22 x 14	22 x 12
2 24 x 19	24 x 16	24 x 14
3 27 x 22	27 x 19	27 x 16
4 33 x 24	33 x 22	33 x 19
5 35 x 27	35 x 24	35 x 22
6 41 x 33	41 x 27	41 x 24
7 46 x 38	46 x 33	46 x 27
10 55 x 46	55 x 38	55 x 33
12 61 x 50	61 x 46	61 x 38
15 65 x 54	65 x 50	65 x 46
20 73 x 60	73 x 54	73 x 50
35 81 x 65	81 x 60	81 x 54
30 92 x 73	92 x 65	92 x 60
40 100 x 81	100 x 73	100 x 65
50 116 x 89	116 x 81	116 x 73
60 130 x 97	130 x 89	130 x 81
80 146 x 114	146 x 97	146 x 89
100 162 x 130	162 x 114	162 x 97
120 195 x 130	195 x 114	195 x 97

Table of different formats (in inches)		
Number F – Figure	L – Landscape	S – Seascape
0 7 x 5½	7 x 4½	7 x 4
1 8½ x 6½	8½ x 5½	8½ x 4½
2 9½ x 7½	9½ x 6½	9½ x 5½
3 10½ x 8½	10½ x 7½	10½ x 6½
4 13 x 9½	13 x 8½	13 x 7½
5 14 x 10½	14 x 9½	14 x 8½
6 16 x 13	16 x 10½	16 x 9½
8 18 x 15	18 x 13	18 x 10½
10 21½ x 18	21½ x 15	21½ x 13
12 24 x 19½	24 x 18	24 x 15
15 25½ x 21½	25½ x 19½	25½ x 18
20 28½ x 23½	28½ x 21½	28½ x 19½
25 32 x 25½	32 x 23½	32 x 21½
30 36 x 28½	36 x 25½	36 x 23½
40 39½ x 32	39½ x 28½	39½ x 25½
50 45½ x 35	45½ x 32	45½ x 28½
60 51 x 38	51 x 35	51 x 32
80 57½ x 45	57½ x 38	57½ x 35
100 64 x 51	64 x 45	64 x 38
120 77 x 51	77 x 45	77 x 38

Composition

The correct balance between forms is of paramount importance in landscape painting. More often than not the choice of format is obvious. However, when it comes to structuring a composition, the rule by which the horizon is placed in the upper or lower third of the painting gives pleasing results. It is advisable not to place it on the centre line (areas that are too equal will seem monotonous) or too low – unless you are really trying to suggest a particularly heavy, threatening sky!

You will then have to decide on the different elements that come into play: the foreground – the shore, some boats, or waves lapping at a landing stage – the middle distance and the background. In the distance, forms become blurred and contrasts are less marked. The colour of the sea becomes uniform and cooler in tone.

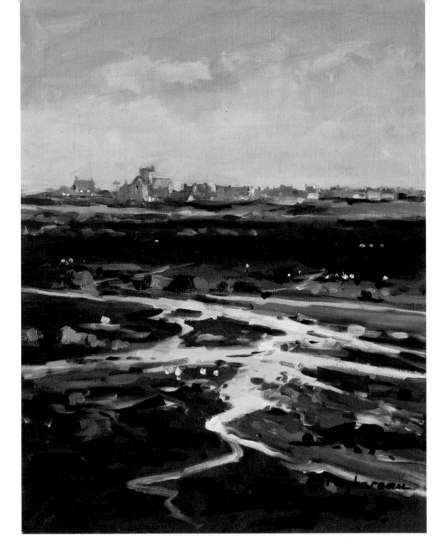

Opposite:
Annie Puybareau,
Low tide at Barfleur.
Oil on canvas, 35 x 27 cm (14 x 10½ in). The horizon is in the upper third of the painting.
© Adagp, Paris, 2006.

Below:
Gérard Barthélemy,
Around Brignogan.
Oil on canvas, 50 x 100 cm (19½ x 39½ in). The horizon is in the lower third of the painting.

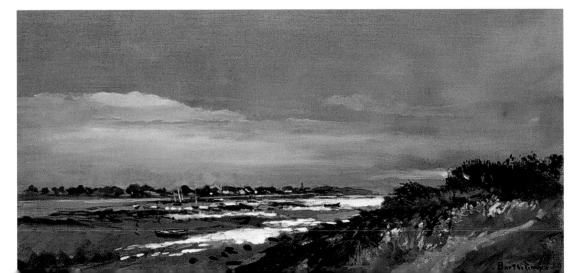

Colours and materials

A large stretch of water in a seascape influences the colours of everything around it. A grey sky with no reflections dulls nuances of colour, whereas bright sunlight lights up the scene you wish to paint. Each plane of the landscape has its own value and colour which you must reconcile using effects of light and shade.

The interplay between materials will make your seascapes more expressive. A brush stroke with a very small amount of a pale colour applied quickly over a dark layer conveys wind blowing over sand, or stubby vegetation growing on a rock. Paint applied with a palette knife creates impasto, which changes according to pressure, direction and the shape of the knife. A thickening medium used as a base layer will give texture to the painting. It can easily be made by mixing very fine white sand with acrylic resin and water. You can paint over it when it is dry. Do not forget that it is applying flat colours and thick colours alternately that will make the painting vibrant and attractive.

TIP

A few basic colours for seascapes: yellow medium, orange, alizarin crimson, violet, ultramarine, cobalt blue, cerulean blue, turquoise, raw and burnt umber, ochre, bladder green, light green, emerald green, Payne's grey, white (not for watercolours), black.

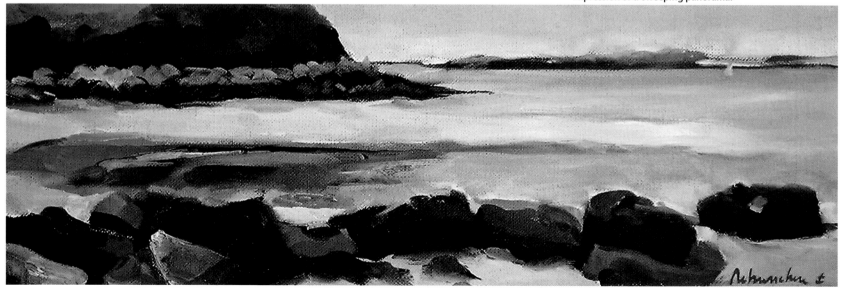

Christoff Debusschere, *Kersaint.* Oil on canvas, 25 x 75 cm (10 x 29½ in). Strong colours and parallel planes create the impression of a sweeping panorama.

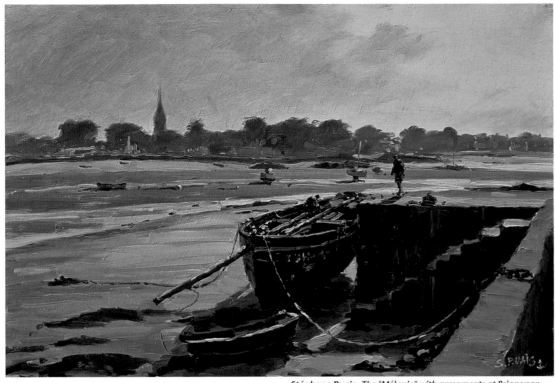

Stéphane Ruais, *The "Mélanie" with armaments at Brignonan.*
Oil on hardboard, 38 x 55 cm (15 x 21½ in).

Iffic, *Ribs.* Graphite on paper, 44 x 32 cm (17 x 12½ in).
The play of the ribs in the boat's frame is heightened
by the effect of chiaroscuro.

Light

Light gives shape to forms. It creates volume, spreading harmoniously over areas which are in sunlight and those which are in shadow. In the oblique light of the morning or the evening shadows lengthen and details are greatly accentuated. At sunset, the sky and the sea are ablaze with red light and very warm tones. In the middle of the day, when the light source is directly above, shadows are very short, contrasts are very strong and colours are intense.

Luminosity in a painting can be achieved in two ways: either by using contrasting values – chiaroscuro, moving from dark to light by gradation (movement from warm light to warm dark is achieved by applying a cool tone) – or by using contrasting colours, as practised by the Impressionists and the Fauvists. The dark part of a painting is treated with a blue which has the same value as the orange of the part in the light. The transition from one to another is achieved using a complementary cool colour – a violet or a green.

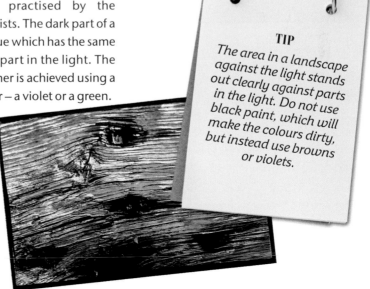

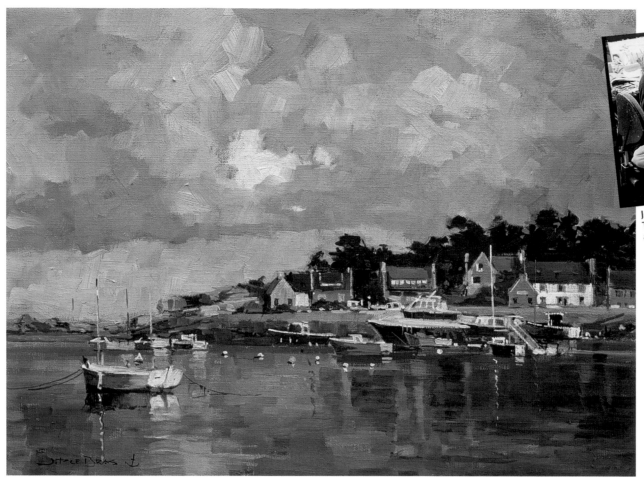

Jean-Pierre Le Bras in his studio.
The artist reworks the shape of a rock to give
a better balance to the subject matter.

Jean-Pierre Le Bras,
Ploumanac'h Harbour.
Oil on canvas, 54 x 73 cm (21½ x 28½ in).
On a calm sea the reflections of
the clouds and the boats mingle.

Back at the studio

After three hours of painting outdoors the body gets tired, the hand becomes heavy and concentration flags. The wind, the sun and sometimes rain triumph over your resistance to the elements. That means it's time to go home!

In the studio, leave your canvas for a day or two, then look at it carefully in a good light, as close as you can get to the light you had when you were painting. You will see what needs to be corrected – the layout perhaps, or the values. A quay with the wrong perspective or a rock which is too dominant can be removed using a cotton pad soaked in turpentine. Then continue the drawing using a fine brush and paint the same colour as the subject matter. If necessary, extend the beach or the stretch of water, keeping the same tonality. You can add some new elements to parts of the painting that are too empty – the reflection of a boat in the water, some ropes, some nets on a beach, a flag or some seagulls. A cloud in an intensely blue sky shows the direction of the wind and adds a vibrant note. You can change the atmosphere of your seascape and make it more dramatic by accentuating the values of the sky and the sea without changing the colours.

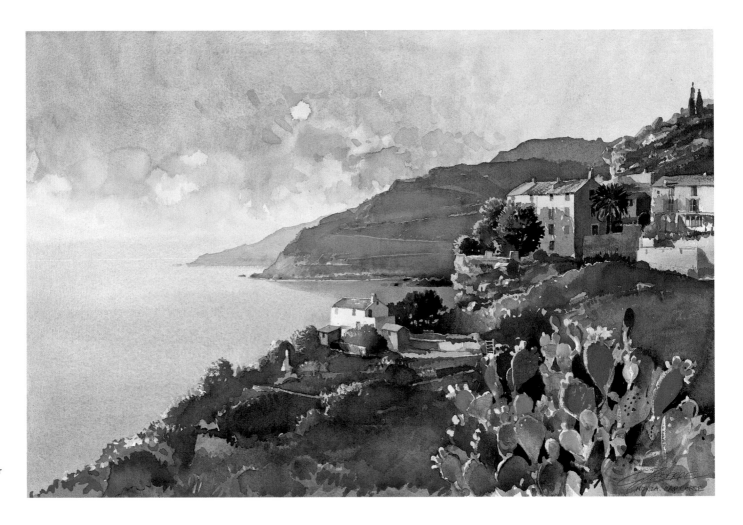

Gérard Leserre,
Morning at Cape Corse.
Watercolour on paper
34.5 x 51 cm.
The wet technique used for
the far distance gives the
feeling of summer heat.

It is also possible to correct a watercolour painting. You may have accidentally touched a boat's sail or the contours of a rock with the blue of the sea with an over-enthusiastic brush stroke . Dilute the colour to be removed with a moist paintbrush. Wipe the brush and then quickly and repeatedly lift off the paint in the area where the paint is diluted. Use a natural sponge to modify a large area with blurred edges; it will prevent obvious marks and rings.

You can get back to the white of the paper (to restore a reflection, for example) by scratching the dry colour with a sharp blade or the point of a scalpel. If you then moisten the paint again you will get a frothy effect which represents the foam of the sea well.

Finally, if your watercolour looks a bit flat when it is completely dry, you can modify the relationship between the colours, consolidate some parts or

apply a glaze. Moisten the surface evenly with a flat grey squirrel-hair brush and then remodel the forms as you wish.

The use of wet and dry techniques in the same painting creates the effect of perspective, and contrasts in material give relief to the work.

Painting on a boat

When a boat is afloat, it of course moves! It is windy and space is restricted, so you should be as lightly equipped as possible. Painting on board either a small sailing boat or a huge liner requires speed and good powers of observation. The constant movement and changing light mean you have to be decisive. Spontaneity is essential.

Guy L'Hostis, *Sailing along the Caribbean coast off Saba.* Watercolour on paper, 41.5 x 57 cm (16½ x 22½ in).

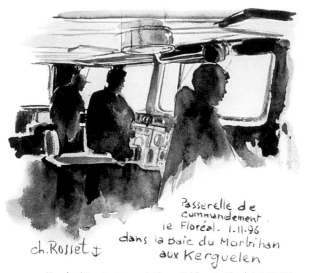

Passerelle de commandement. le Floréal. 1.11.96. dans la Baie du Morbihan aux Kerguelen

ch. Rosset

Handwritten text on painting – Bridge, Le Floréal. 1.11.96. in Morbihan Bay, Kerguelen, Christiane Rosset. Chinese ink wash on Chinese paper, drawn on board the bridge of the Floréal. © Adagp, Paris, 2006.

A different point of view

Once on board find a spot in the shade where you have something to lean on, to be as comfortable as possible and keep your balance whether you're sitting down or standing up. Prepare your sketch books, pencils, felt-tips and your box of watercolours. Sailing along deserted coastlines provides magnificent views of jagged overhanging rocks, cliffs streaked with foam, a small harbour, a village of small squat houses – so many subjects all rich in detail. Train your eye to find subjects with limited detail. Do a simple drawing of the subject matter's structure in its dominant colour – brown, a warm tone, or Payne's grey, a cool tone. Work quickly, as the result will then appear much more

authentic. On the boat itself, use foreshortened views whenever possible: looking down onto the bridge, the equipment or the sailors from above. Take advantage of being on the open sea to study the movement of the swell and the reflection of the clouds in the water at close hand. Make a note of your impressions and some practical details (place, time, direction, luminosity of the sky, colour of the sea, etc) on all your drawn and painted sketches. Back on land you will use your notebooks and notes to provide you with the myriad details that will nourish your imagination, and without which your paintings would not exist.

Dan Jacobson, *On board the yacht Patriach*. Quick sketch using the tip of the brush, colourwashes, white spaces free of colour. © Adagp, Paris, 2006

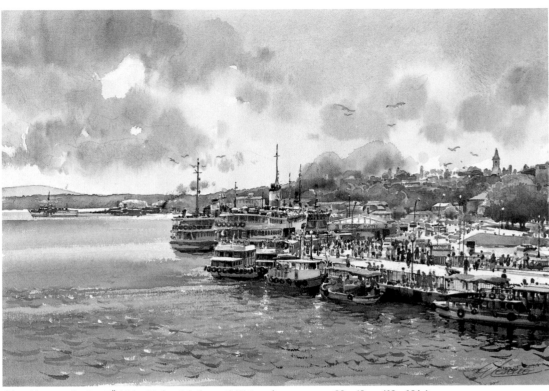

Gérard Leserre, *Ferries at Üsküdar (Turkey, Asiatic coast)*. Watercolour on paper, 33 x 48 cm (13 x 19 in). Small vertical lines of colour convey the bustling atmosphere of the ferries alongside the quay.

Invitation aboard

A liner cruise lasts several days, which gives the opportunity to make multiple sketches, some more finished watercolours and even some small oil or acrylic paintings. Do not exceed the 50 x 60 cm format, or stretcher no. 10. Consider using canvas board which is less cumbersome and easier to manage. Take advantage of a long trip to paint scenes of life on board – tourists relaxing or sailors working, equipment, dinghies, rigging, etc.

The Official Painters to the Navy sail across the seas of the world on war ships, returning from their missions with an endless supply of images. Inflammable materials, including turpentine, are not allowed on board ship, which means that painting with oils is not possible. A warship is like a town bustling with activity – there are a lot of people and very little space. It is not always easy to do a large watercolour painting, but the marine painter can fill sketchbooks with pencil, pastel, felt tip or coloured ink drawings. Each is an invaluable record of distant campaigns and, at the same time, a wonderful call to set off again.

So what are you waiting for? Raise the anchor!

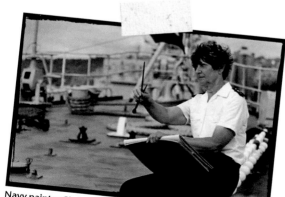

Navy painter Christiane Rosset starts painting from the moment she arrives on board.

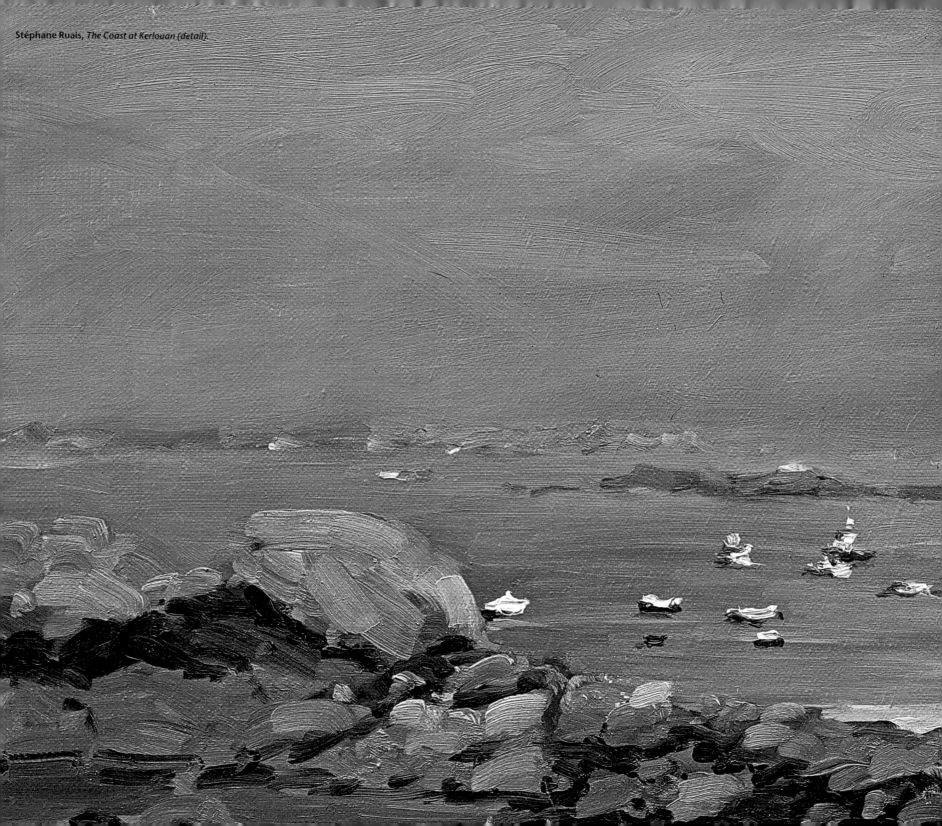

Stéphane Ruais, *The Coast at Kerlouan (detail)*.

The paintings,
step by step

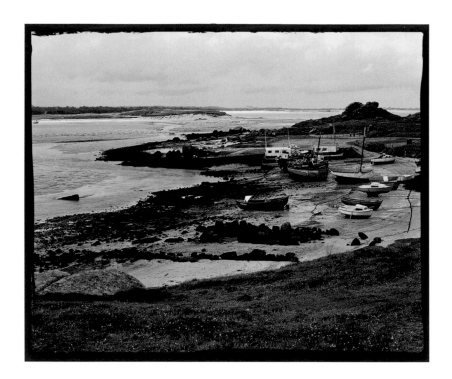

STÉPHANE RUAIS
The fishermen's dock

Windswept dunes, a rocky shore line, black seaweed, pink sand covered, uncovered and covered again with the rhythm of the tide – this is a landscape that Stéphane Ruais is particularly fond of. He sets up his easel yet again in the place known as 'The fishermen's dock', against a backdrop which taught him from an early age about the many effects of light on the natural elements – land, water, sky and clouds.

Composition

Stéphane Ruais has set up his easel on a dune over-looking Kernic bay. The landscape stretches out in front of him on several planes: first, the edge of the dune covered in green grasses, the sand, a low wall of rocks and the ruins of a megalithic covered walk-way; then further away, the beached fishing boats, the small rocky headland on the right and a strip of land on the left; then finally, the sky meeting the sea and a coastline in the distance. A channel of sea water describes a huge 's' shape, cutting across the regularity of these planes. The artist arranges his subject matter along this curving line, emphasizing the importance of the channel and leaving a large space for the sky.

Technique

On a fine canvas which he has primed with white acrylic, the painter defines the general tonality of the painting with a few colourwashes – a bluish grey for the sky, an ochre tone for the beach, a grey-green for the sea. This initial work is done with a large flat brush that covers the surface quickly. He continues by applying thicker paints that cover well, to which he has added a little glaze medium to lift the flatness of the dark colours. He uses medium fine brushes with very soft hair and applies the colour gently to avoid any trace of brush strokes.

Colours used

Emerald green, chromium green, ultramarine blue, alizarin crimson, Van Dyke brown, raw umber, yellow ochre, orange, permanent yellow deep, cadmium yellow, titanium white

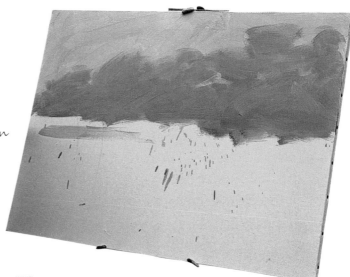

1 Stéphane Ruais arranges his colours on the palette: the greens at the front, the ultramarine, crimson, browns, ochre, orange and yellows at the top and a generous amount of white on the right. The paints will be mixed with turpentine in the centre of the palette.

3 Above the horizon, almost half way between the top and the bottom of the painting, some darker clouds have gathered. The painter expresses them using a cool solid grey obtained by adding a little ultramarine blue to the previous mix. As a result, the horizon will be slightly lower.

2 The sky establishes the atmosphere of the painting to come. The artist quickly covers the upper part of the canvas with a very thin grey colourwash, a mix of white, permanent yellow deep, Van Dyke brown and a touch of ultramarine blue.

TRADE SECRETS

Stéphane Ruais has set up a large box with six compartments in the boot of his car. He can store both unused and freshly painted canvases in it, without them touching each other.

51

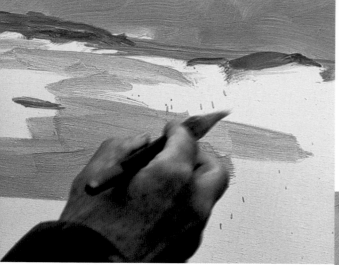

7 He paints the grassy areas with a mix of green, yellow and white, the jetty with a line of very deep grey. He blends the strokes into each other to avoid abrupt changes in the colours.

^4 He paints the large stretches of sand with wide strokes in a warm, luminous colour made up of yellow ochre, orange and plenty of white.

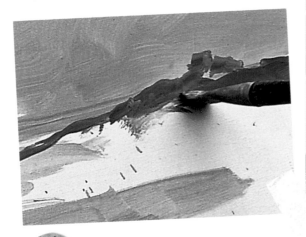

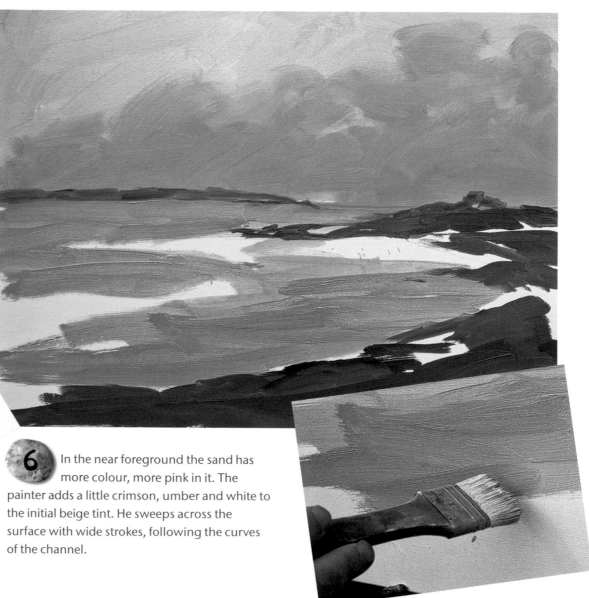

5 The horizon is edged with grey-green heath, like the headland to the right of the channel entrance. The painter has added some yellow and some blue to the grey of the sky. The colour is applied with wide strokes of 'fat' paint to indicate the relief of the land.

6 In the near foreground the sand has more colour, more pink in it. The painter adds a little crimson, umber and white to the initial beige tint. He sweeps across the surface with wide strokes, following the curves of the channel.

8 Positioned on a rocky outcrop, Stéphane Ruais can take in the whole of Kernic bay and the fishing boats sitting in dry dock.

9 > For the projecting rocks covered in dark moss or black kelp, the artist adds a little raw umber and Van Dyke brown to the green mix.

10 Stéphane Ruais goes back to the light grey mix of the sky on his palette and adds some ultramarine blue and some white to obtain the shade of the water in the channel. The whole of the water's surface reflects the varying tones of the sky.

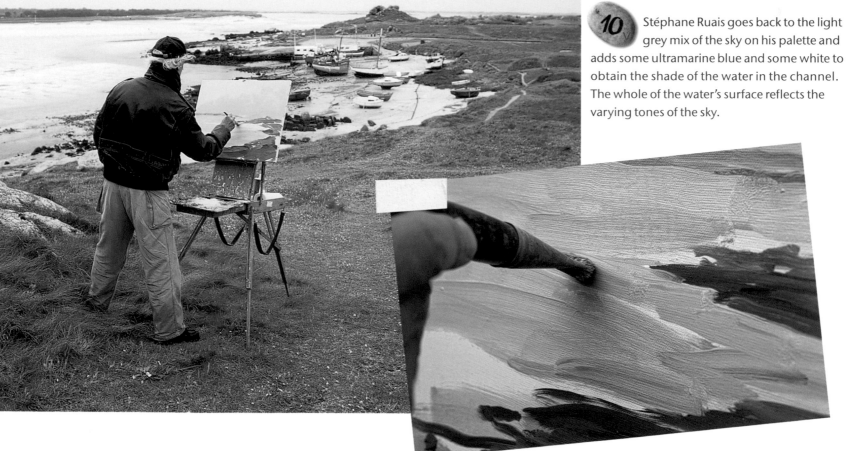

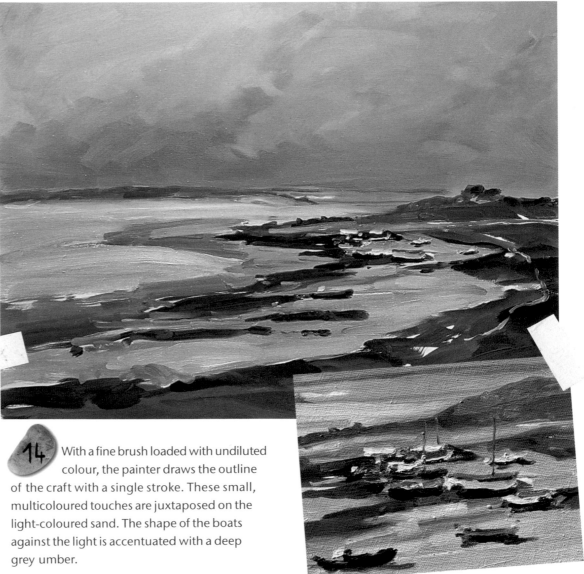

13 The marine landscape is now wholly in place. He has added the touches of colour in small dabs close to each other, to animate the surface.

11 He paints the channel with a slightly thinned paint, following the curves of the shoreline. Several layers blended together create relief. A small quantity of medium added to the paint improves the adhesion of the layers.

12 Stéphane Ruais reworks the whole painting with a thicker paint to enhance the colours, while still maintaining the same scale of values he established with the first colourwashes. He begins with the sky, which becomes heavy with thick grey clouds.

14 With a fine brush loaded with undiluted colour, the painter draws the outline of the craft with a single stroke. These small, multicoloured touches are juxtaposed on the light-coloured sand. The shape of the boats against the light is accentuated with a deep grey umber.

15 Stéphane Ruais goes back to the colours of the rocks, which also have the light behind them. He makes the greys darker by adding some Van Dyke brown mixed with ultramarine blue. The contrast with the lightness of the sand increases the luminosity of the landscape.

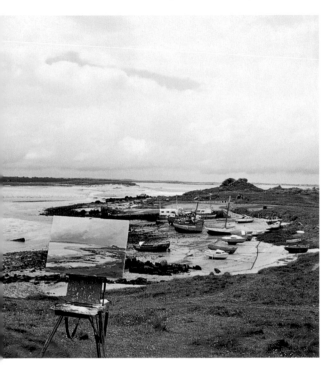

16 In the foreground the painter uses a deep green for the rocky outcrop where he is positioned. In the middle distance the light, warm tones of the sand are interrupted by the blue of the channel and cut across by lines of almost black rocks, brown kelp and dark green moss. In the background, the nearly white sand creates the impression of distance. The clouds, low on the deep grey horizon, contrast with the upper part of the sky which is bright and luminous.

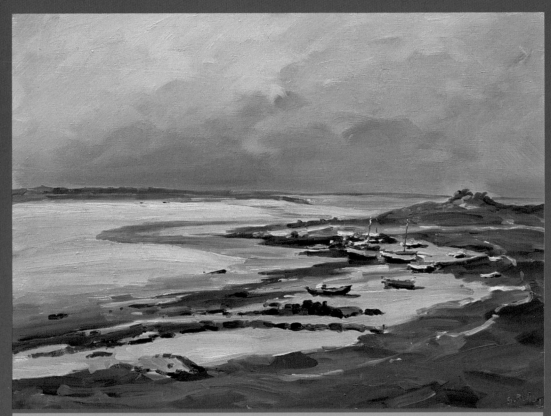

The fishermen's dock. 54 x 73 cm (21½ x 28½ in).

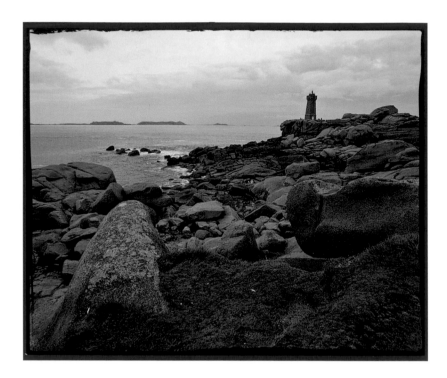

JEAN-PIERRE LE BRAS
Lighthouse and rocks at Ploumanac'h

Jean-Pierre Le Bras never grows tired of painting the masses of pink granite to be found on Brittany's Armor coast. He has decided to set up his easel at the edge of a small inlet overlooked by Ploumanac'h lighthouse. The tide is beginning to rise. At this time of the morning the sun is already high in the sky and almost directly in front of him. The rocks, worn away by the sea, present the painter with a huge array of colours and forms intensified by the light from behind.

Composition

From the Custom Officers' Route where he has set up his easel, Jean-Pierre Le Bras overlooks the small inlet, which will be covered by the tide in a few hours' time. On his right, the tall silhouette of the lighthouse reaching up towards the sky balances the horizontal elements of the composition. In the distance, the 'Seven Islands' mark the horizon. The cloudy sky fills the upper quarter of the painting. A wide area is given over to the open sea on the left hand side. In the foreground, the heaps of red, ochre and brown rocks form a dark mass which heightens the luminous impact of the sea and creates the depth of the composition.

Technique

Jean-Pierre Le Bras has had the colours of Brittany – the often-painted land of Trégor – in his heart and at the tip of his brush for a good many years. That does not stop him from going back to the subject to rediscover the atmosphere that he loves so much. Usually he starts a painting and then, when the tide begins to make things difficult for him, finishes it in the studio. He uses creamy paint thinned a little with a medium of half linseed oil and rectified turpentine. He applies his strong mixed colours with wide, bold strokes. Occasionally he uses a palette knife to shape the thick paint and make the light bounce off it.

Colours used

Cassel earth, Van Dyke brown, Mars yellow, yellow ochre, transparent orange, madder lake, ultramarine blue, cobalt blue, titanium white

3 The painter sketches in the horizon two thirds of the way up the painting. He fills the sky with a mix of ultramarine blue and white enriched with a hint of madder lake and yellow ochre, using a medium brush. The brush strokes must not appear too heavy.

1 Before he starts painting outdoors, Jean-Pierre Le Bras primes his canvases with a mauvish background which takes away the glare of the white and creates atmosphere. He looks carefully at the landscape and defines its boundaries in his mind.

2 He begins by drawing the contours of the rocky masses and the lighthouse. He uses a fine brush loaded with a Cassel earth colourwash thinned with turpentine.

4 He accentuates the contours of the islands on the horizon with a line of pinkish grey. The sea is painted with the same tones as those of the sky. A lighter, broad line in front of the islands creates depth. The waves in the foreground throw white foam up onto the rocks.

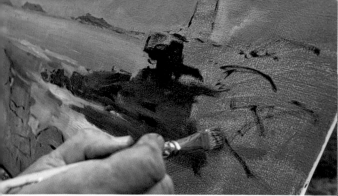

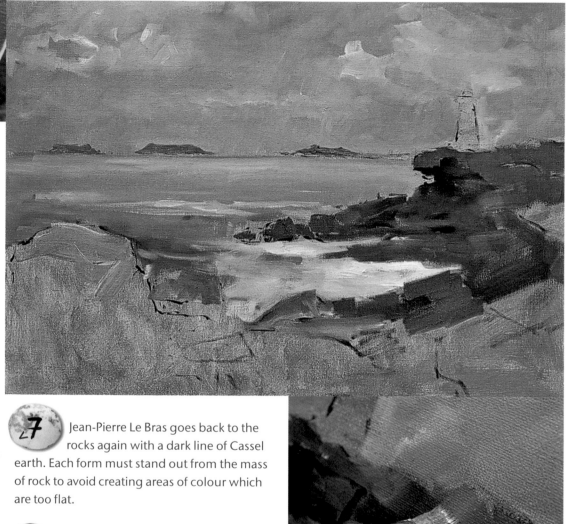

5 The painter is working on the rocks. He is looking for a dominant colour for the pink granite rock face; it will be a mix of Van Dyke brown, Cassel earth, Mars yellow and madder lake.

6 The colour is applied flat with wide strokes following the shape of the rocks. A preliminary layer in a medium tone is covered by deeper colour which creates relief.

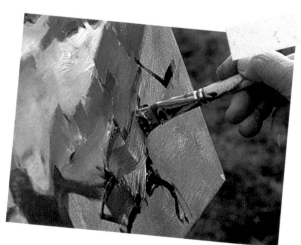

7 Jean-Pierre Le Bras goes back to the rocks again with a dark line of Cassel earth. Each form must stand out from the mass of rock to avoid creating areas of colour which are too flat.

8 He applies the colour with generous strokes of a wide brush. Each movement follows the jagged form of the granite rocks.

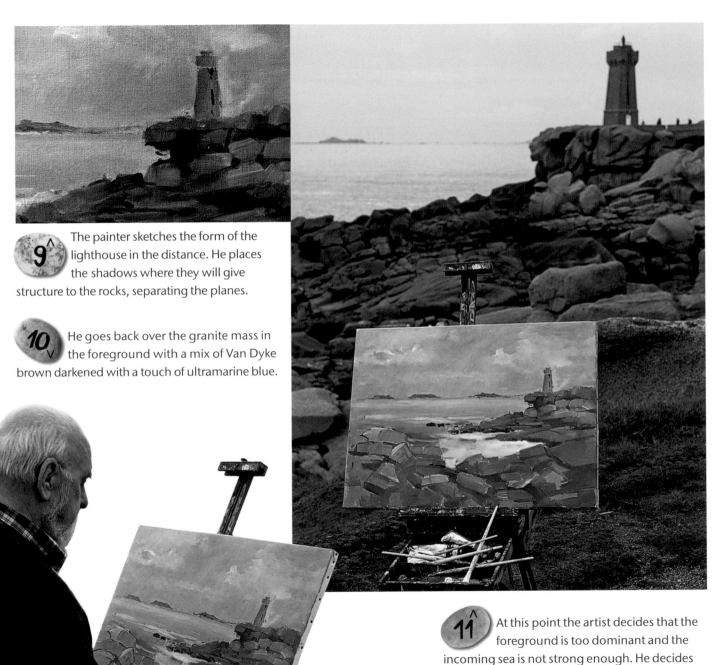

9 ^ The painter sketches the form of the lighthouse in the distance. He places the shadows where they will give structure to the rocks, separating the planes.

10 ᵥ He goes back over the granite mass in the foreground with a mix of Van Dyke brown darkened with a touch of ultramarine blue.

11 ^ At this point the artist decides that the foreground is too dominant and the incoming sea is not strong enough. He decides to rework the composition in the studio.

TRADE SECRETS

A restricted palette contributes to the harmony of a painting as long as the colours chosen combine pleasantly with each other. Chromatic balance is easier to find with a few colours that are close to each other than with several very different colours.

59

12 ∨ He erases part of the foreground with a cloth soaked in turpentine to lessen the impact of the mass of rocks, which is too prominent.

14 > He strengthens the dramatic character of the landscape by accentuating the shadows of the rocks with a dark line. The whites seem more luminous.

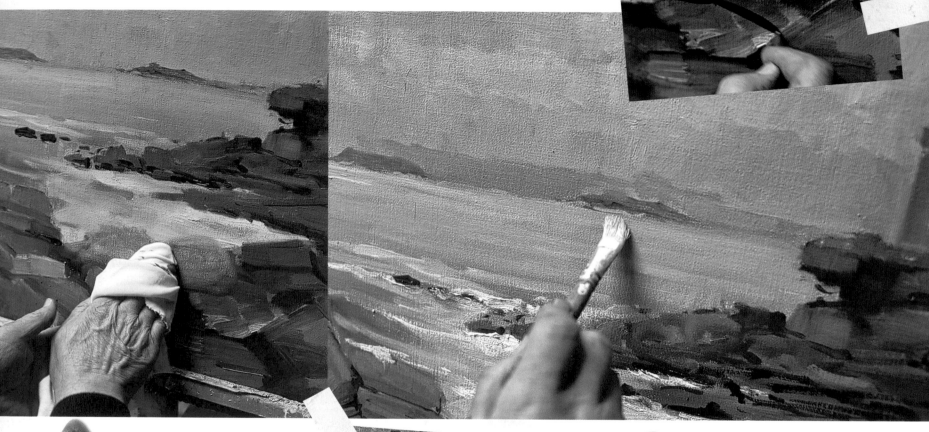

13 > He covers the area he has just wiped out with the tip of a brush loaded with pure white. He can animate the surface of the sea by applying small touches of white with some pink or blue added for the crests and troughs of the waves.

15 ^ A line of light colour highlights the island shores and pushes them back towards the horizon, creating depth.

16 He picks up the sea in the centre of the composition in brighter tones, a mix of cobalt blue and ultramarine with a little white added.

17 > The breaking waves hitting the rocks create a boiling foam with sparkling reflections. The difficulty is to show the movement of the water using simple forms. The brush strokes must be confident, as an overworked foreground would take away all the dynamism.

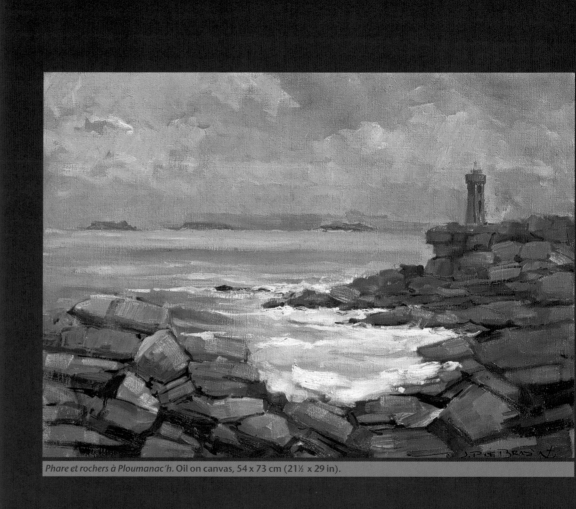

Phare et rochers à Ploumanac'h. Oil on canvas, 54 x 73 cm (21½ x 29 in).

JACQUES COQUILLAY
Ailly Beach at Pourville

On the day Jacques Coquillay has chosen, the weather at Pourville is superb. He has positioned his easel on the beach of this village near Dieppe and opened his box of quality pastels. Low tide has revealed a wide stretch of shingle and sand which is dominated by a huge, sheer cliff. In the distance the coast line blends into the sky. The colours, the contrasts and the interplay of light and shade will enable the artist to give this landscape a warm atmosphere with vivid colours.

Composition

The wide and open landscape looks bare, but the painter's experienced eye can find substance in it for a harmonious composition full of contrast. A large area of shadow covers the shingle in the foreground. The cliff, also in shade, runs along the right side of the painting. The alternating strata of white chalk, yellowish marl and dark flint give it a milky, muted colouring. The sky has no limit, nor has the sea, which seems vast.

Technique

Jacques Coquillay works with dry pastels on cachou brown Canson Mi-Teintes paper glued onto card. The colours work better together on neutral-coloured paper than on white, which dazzles. The artist prepares his paper with a layer of pastel applied flat, then blends it with his finger or the palm of his hand. He juxtaposes the colours, using his finger to blend one with another. If he applies one colour on top of another, he is careful to maintain the freshness of the first colour in order not to cover it up. He works on an upright support, so the pastel powder falls into the box-easel when he blows on it. The fixative is sprayed onto the pastel when the work is finished to prevent the colours from being spoilt, but never when it is in progress.

Colours used

Turquoise blue, cobalt blue, Naples yellow, pale yellow, yellow ochre medium, yellow ochre light, pink beige, flesh, green light, moss green, brown, Payne's grey, greenish-grey, orange, red, black, white.

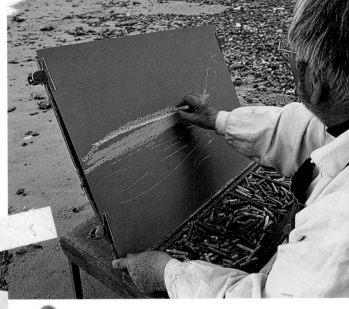

1 ⌄ Jacques Coquillay has found a space in the shadow of the cliff. The open box-easel acts as a support for a sheet of dark-coloured Mi-Teintes paper glued onto card.

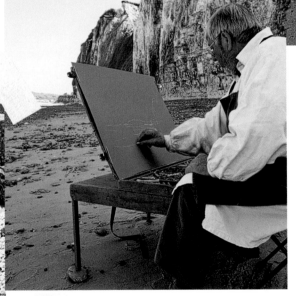

3 ∧ First the artist establishes the horizon, the blurred line separating the sky from the sea. He begins by working on the sky, the most luminous element of the painting.

2 By carefully observing the subject he is about to tackle, the painter establishes the composition of the painting in his mind, the guiding lines being the vertical lines of the cliff, the horizontal lines of the consecutive planes and the vast area of the sky.

TRADE SECRETS

A large pebble can act as a wedge for the foot of the easel and establish a firm base on a sloping beach.

4 The brightness and depth of the sky are achieved by applying several layers of turquoise blue pastel. Superimposing layers of powdery material feeds the paper.

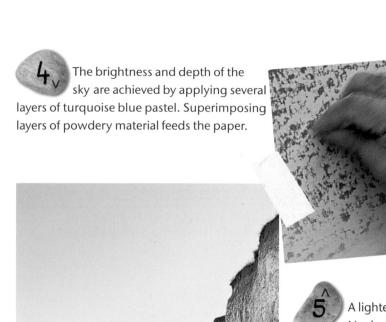

5 A lighter line, a mix of pale ochre and Naples yellow, emphasizes the depth of the far distance. The sky is worked as a whole, in what will be its final colour.

6 The juxtaposed layers of turquoise blue, white and pale yellow are softened and blended with the fingers to suggest a slight effect of mist in the distance.

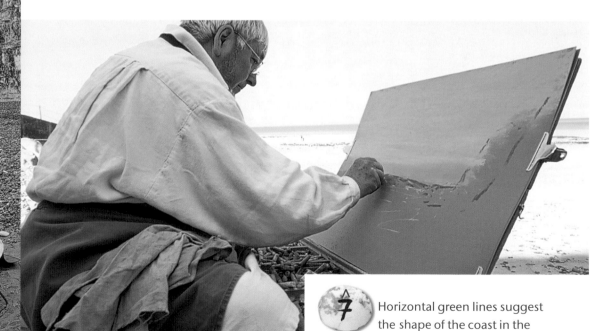

7 Horizontal green lines suggest the shape of the coast in the middle distance of the composition.

8 The beach, the village and the green headland are evoked by using small splashes of colour. The cliff on the right is portrayed by deep brown hatching which stands out against the rest of the composition.

9 v The sky and the sea are now finished. The artist is going to tackle the foreground of the painting next, starting with the large cliff on the right.

10 v As the sun follows its course, it breaks through onto the limestone at the top of the cliff. A splash of bright light gilds the cliff face.

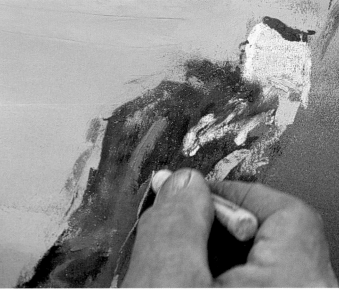

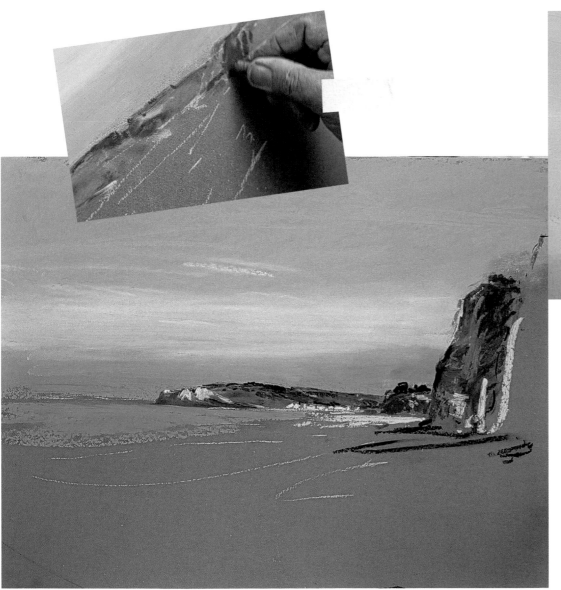

TRADE SECRETS

The artist keeps the colours he uses most often in his hand to avoid wasting time looking for them in his box (which holds more than 600!).

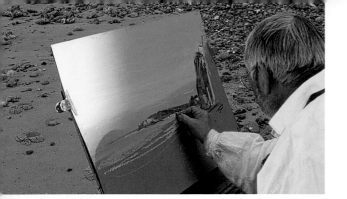

11 The sun is gaining ground and shining directly on the painting, which distorts the colours. Jacques Coquillay is going to move his easel, to stay in the shade.

12 The sea is slowly creeping up the sand on the beach. Lines of pale blue pastel animate the surface of the water which glints in the sunlight.

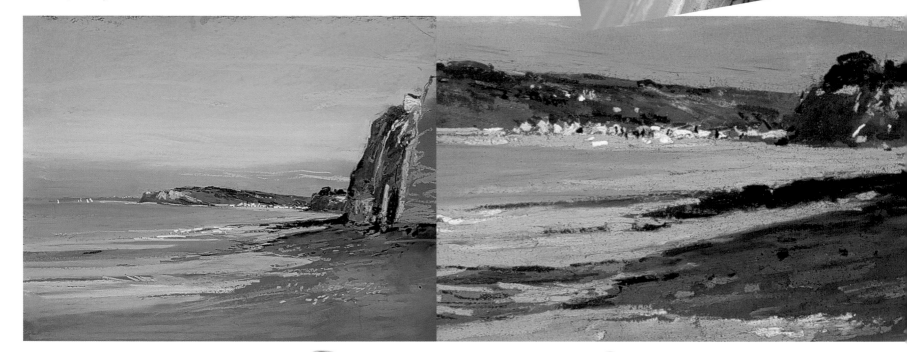

13 Browns, yellow ochres, pinks, and greeny-greys cover the cliff, the sand and the shingle in the foreground with mineral tones. The strong shadows contrast with the colours in the background, which is bathed in sunlight.

14 Small splashes of orange-red evoke the roofs of the houses. They are in cheerful contrast with the green tones next to them. The shadows on the cliff face and the sand are darkened with blues.

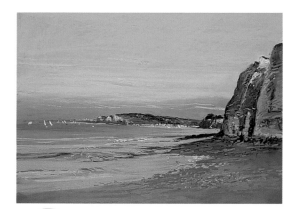

15 The outdoor work is now finished. The horizon is positioned slightly below the mid line of the painting. Jacques Coquillay has avoided making the painting monotonous by contrasting the warm tones of the strip of land in the distance with the cool tones of the sea and the sky.

16 Back in the studio, the artist has put a few clouds in the sky to give the composition more impact. These wispy lines of yellow and pale pink pastel follow the slanting lines of the strips of land in the distance, which reinforces the guiding lines of the painting.

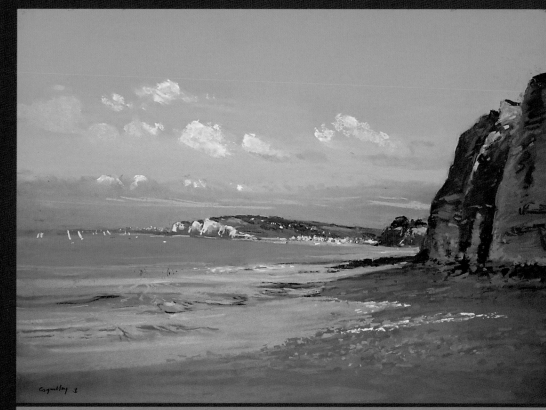

Ailly Beach at Pourville. **Dry pastel on tinted paper glued onto card, 54 x 73 cm (21½ x 28½ in).** © Adagp, Paris, 2006.

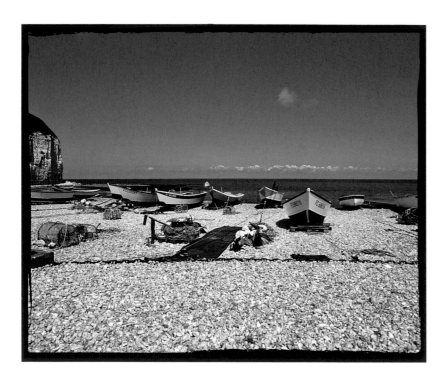

ANNIE PUYBAREAU
Fishing boats at Yport

Breaking the monotony of the long stretches of beach bordered by sheer cliffs on the Upper Normandy coast, the shingly beaches of the village of Yport play host to the brightly coloured fishing boats of the local fishermen. Annie Puybareau has painted this landscape from many different angles, always with the same passion for its joyful, transparent atmosphere bathed in light.

Composition

Annie Puybareau has chosen a frontal view, set out on several planes – the ropes and fishing pots, the boats, the sea and finally, the sky streaked with a horizontal band of clouds. She has made the boats the focus of her composition, ignoring the cliff that borders the beach on the left. At low tide the sloping shingle is covered in black kelp. This dark line in the middle of the composition accentuates the bright colours of the boats. The light from the right casts clearly defined shadows which must be maintained right through to completion of the painting.

Technique

Annie Puybareau paints in the post-impressionist tradition, inspired by the light on the Normandy coast. Her work is based on a structured design and a sound appreciation of value. Her painting is delicate, created by superimposing vivid transparent tones. Her brush strokes are long, applied flat for backgrounds, light and fine in the details. She uses soft square brushes, which she applies flat or in a thin sliver, depending on the thickness of the line. When she paints a seascape she begins with the colours of the sea and the sky on the horizon, which establish the atmosphere of the painting. Then she sets about capturing the value of the shadows, which must be maintained even though the light changes as the day progresses.

3 She draws the tips of the rocks covered in black seaweed and roughly marks the position of the clouds moving across the sky. Holding the brush high up the handle creates a free-flowing and confident painting.

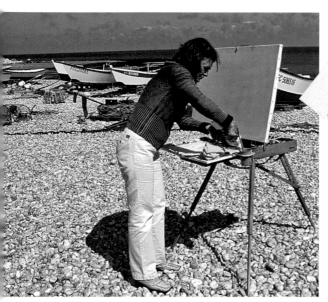

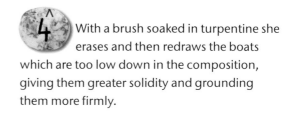

1 Annie Puybareau sets up her box-easel on the shingle near the boats. She has chosen a medium format canvas primed with a layer of light brown acrylic. This colour, which she has applied with a sponge, prevents any glare from the whiteness of the canvas.

2 The artist places the horizon two thirds of the way up the painting and quickly sketches the outline of the boats and the clouds. She uses a small flat brush loaded with a burnt umber colourwash diluted with turpentine, which she applies with a flat stroke to draw straight lines.

4 With a brush soaked in turpentine she erases and then redraws the boats which are too low down in the composition, giving them greater solidity and grounding them more firmly.

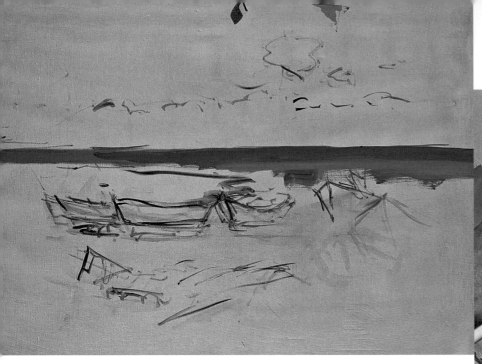

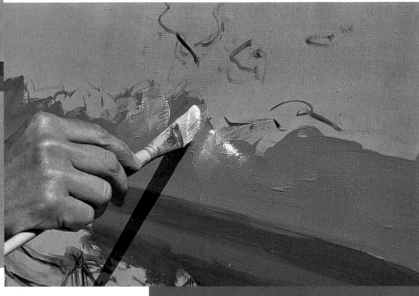

5 ∧ The artist depicts the sea with a line of intense ultramarine blue highlighted with cobalt. She adds a little emerald green and white to the mix in the centre of the composition to convey the sparkling of the water in the sunlight. She applies the colour horizontally in long strokes.

6 To represent the fleecy clouds that fleck the sky above the horizon, Annie Puybareau has prepared a mix of Payne's grey, ultramarine blue and white on her palette, to which she has added a touch of violet and yellow ochre.

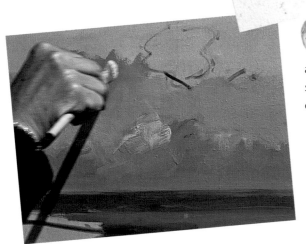

7 The addition of painting varnish to the thick paint gives it creaminess and an adhesive quality. The artist applies short strokes in all directions to build the shape of the clouds gradually.

8 ∧ The upper reaches of the sky are a vivid blue, with ultramarine as the dominant colour. They are linked to the clouds with blends of blue and grey, to which a considerable amount of white has been added.

9 To increase the effect of distance at the end of the beach, the sky and the sea meet on the left with less contrasted tones than those in the centre of the composition. The colours of the water are toned down and blended with those of the sky.

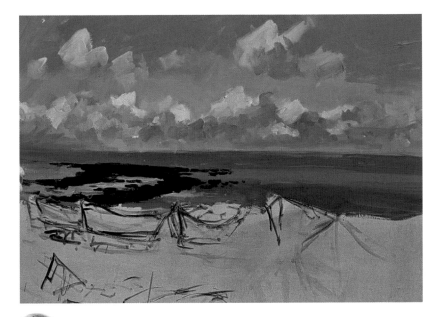

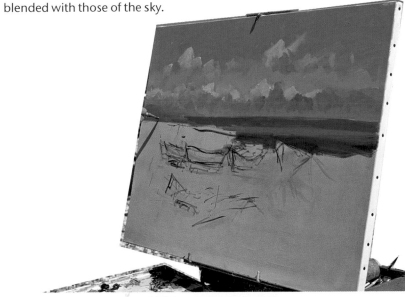

10 Here the artist is working on the kelp-covered rocks with a very dark mix of Payne's grey, ultramarine and burnt umber enriched with a hint of violet and phthalo green. She paints the rocks in yellow ochre and light green tones punctuated with yellow and white.

11 The boats stand out against the dark background of rocks with their clear colours. The artist draws shadows under the hull and on the side of each small craft before the light changes.

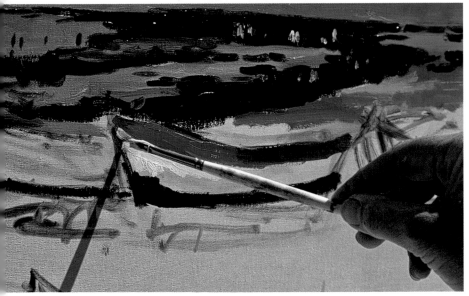

TRADE SECRETS

Annie Puybareau's palette is made up of two plastic trays fitted with a hinge which enables them to close together. For each work session she fastens a sheet of greaseproof paper on the trays with double-sided adhesive. At the end of the day she takes the paper off and throws it away.

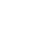

71

12 The sides of the boats are picked out with a line of colour. Splashes of white portray the foam of the waves breaking on the sharp rocks, and bring a luminosity to the scene.

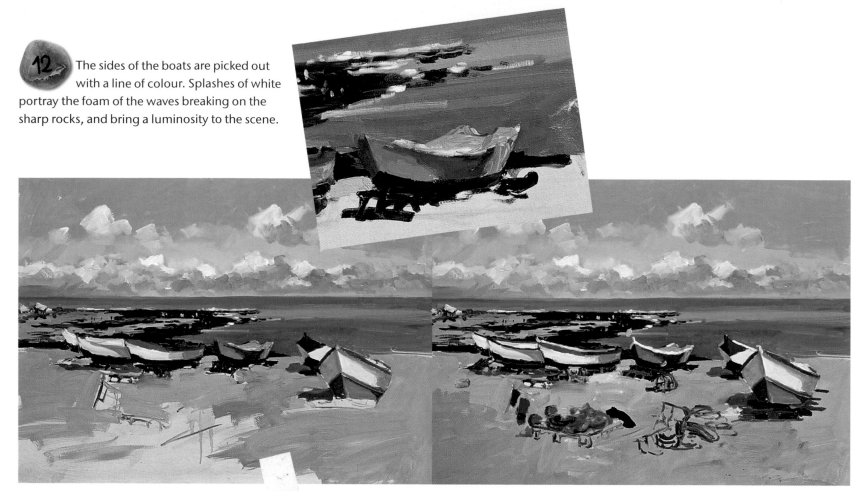

13 The sand is represented by a pink beige mix of thick creamy paint applied with a brush. This colour will be covered by the paint of the shingle.

14 > The artist adds more detail to the shadows beneath the boats and, with a fine brush loaded with brown, draws the wooden wedges that keep them in place on the sand.

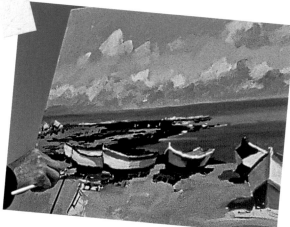

15 Scattered around the boats are ropes, lobster pots, nets, marker flags and wooden pallets. Essential tools for the fisherman, they litter the sand with their splashes of colour.

16 The form of the nets, flags and ropes is painted using short strokes of bright colour applied with the tip of the brush.

17 Annie Puybareau has patiently added some small round spots of grey to portray the shingle in the foreground. She has added a few people walking along the shore and, on the sea, a red ochre sailing boat, some white ships and a fishing boat sailing away from the beach. All these different elements give life to this particularly luminous painting.

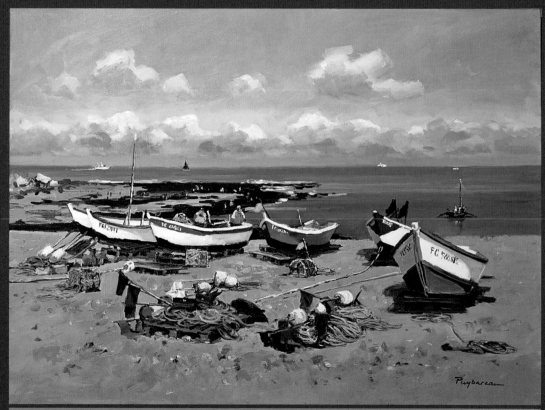

Fishing boats on the beach at Yport. Oil on canvas, 60 x 81 cm (23½ x 32 in). © Adagp, Paris, 2006.

CHRISTOFF DEBUSSCHERE
The fishing port of Dieppe

Everything is grey – the sky, the warehouses, the boats, the water – which by no means upsets Christoff Debusschere. 'I hate blue skies!' he declares. What he does like is to capture on canvas the feeling of abandoned-looking work places and he particularly appreciates simple concrete structures, weather-worn sheet metal roofs, iron girders eaten away by rust. He expresses his emotions through a graduation of grey values, transposing them onto his canvas.

Composition

The interest of this subject matter – which at first glance seems banal – lies above all in the light. In spite of the dominating grey tonality, the luminosity is intense and gives the scene its atmosphere. The artist chooses a vertical element, the crane, as the fulcrum of his composition. He does not try to place a subject in the centre of the painting. He deliberately leaves a space between the two boats, creating depth and at the same time giving scale to the work.

Painting in grey weather runs the risk of having the light change several times during the session. In such circumstances it is better to choose one value and stick to it, to maintain the unity of the painting, even if it means some touching up at the end.

Technique

Christoff Debusschere only needs one session for a painting. He sketches his subject matter in one brush stroke, applying the right colour to convey the form, the material, the mass and the light at the same time. He holds his brush perpendicular to the canvas to apply wide strokes, or on the edge to draw finer lines. He uses wide, flat brushes, worn, rounded hog's hair brushes and fine round mongoose hair brushes. He works on all areas of the painting at the same time.

Colours used

Titanium white, ultramarine blue deep, royal blue, cadmium yellow light, yellow ochre, brilliant yellow, ivory black, cadmium orange, red madder lake, raw umber, emerald green, vermilion green, violet.

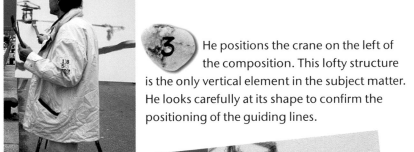

3 He positions the crane on the left of the composition. This lofty structure is the only vertical element in the subject matter. He looks carefully at its shape to confirm the positioning of the guiding lines.

4 ^ He sketches the shape of the boats using a wide brush loaded with fairly thick black paint.

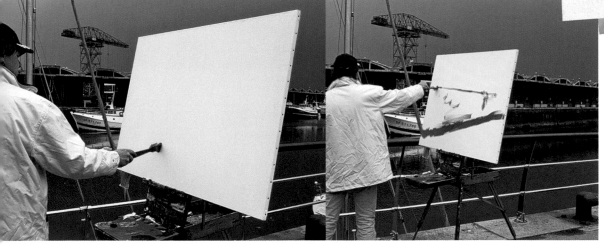

1 ^ Christoff Debusschere has decided to paint on a large, fine linen canvas format 92 x 73 cm, which is possible outdoors if it is not windy. He sets up his easel at the edge of the dock so that his eye can take in the perspective of the warehouses.

2 ^ He sketches the main lines of the subject matter with a brush loaded with thin grey-green paint. The dynamism of the composition is created by the rising line of the quay side and the horizontal line of the warehouse roofs two thirds of the way up the painting.

TRADE SECRETS

Christoff Debusschere uses radiator brushes. The slightly angled ferrule allows him to lay the very dense tuft of bristles flat on the canvas to paint wide lines.

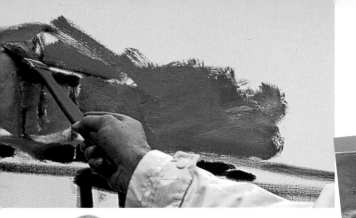

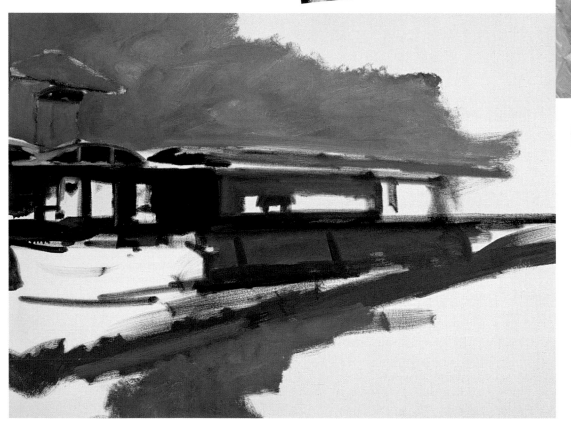

6 He fills the whole of the upper surface of the painting with the same range of greys, alternating the layers of thin paint with strokes of thicker paint.

5 The artist prepares a bluish-grey mix on his palette, finds the tone that is exactly right and faithfully reproduces the colour of the sky. By holding the brush with an outstretched arm he can see the work as a whole.

7 He sketches the metal structure of the warehouses using wide, dark almost black lines.

8 The values of the water and the sky must be equal for the unity of the whole to be maintained. The painter lays his colours down around the boat in the foreground, leaving the boat itself for later. He develops the shapes by his use of colour, creating an impression rather than a resemblance using unnecessary detail.

9 The white of the small trawling boat, tinged with grey and applied in wide strokes of thick paint, makes it stand out against the greyness of the quays.

10 The artist draws a black line under the base of the hull to represent the reflection of the boat in the calm water.

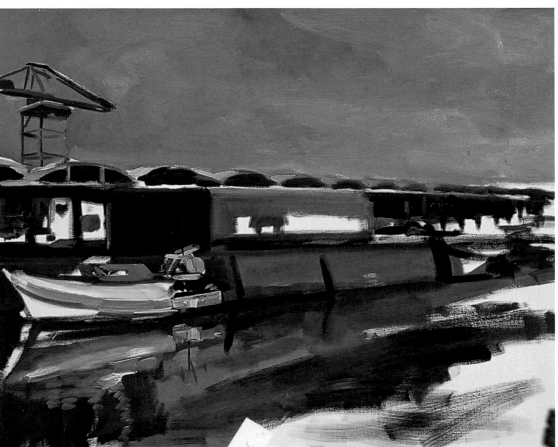

11 The space devoted to the warehouses is deliberately less than in the real-life subject, which gives the composition a more dynamic perspective.

12 Here Christoff Debusschere is starting to finish off and brings in some more colourful tones which brighten up the greys. A few short thin strokes of light green are enough to suggest the silhouette of a crane in the background of the painting.

14 Christoffe Debusschere works on the area in the middle, painting the blue doors of the warehouses. He sketches the boats in the distance in white and blue, his brushstrokes following the lines of the small craft.

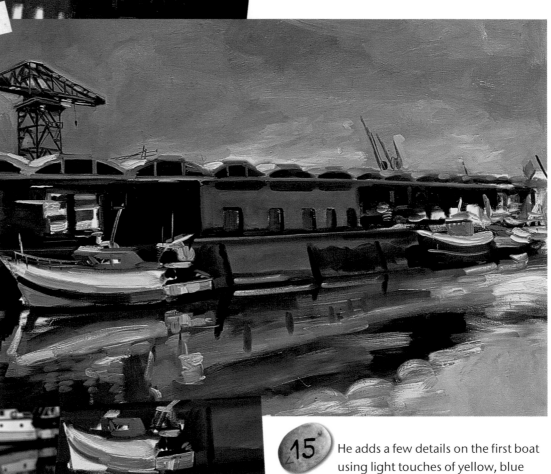

13 The artist comes back to the colours of the sea. There are light and dark areas in the calm water of the dock created by the shadows of the buildings around it.

15 He adds a few details on the first boat using light touches of yellow, blue and orange. The reflections on the water are created in a lighter tone than that of the object they reflect.

16 He comes back to the lines of the crane to fix its orientation and give it presence by maintaining its lofty aspect. The colour of the sky around the crane is intensified, as the crane must blend with the sky rather than appearing to be placed on top of it.

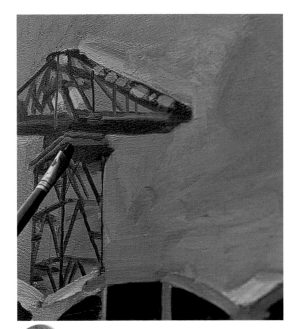

17 The luminous area of the painting is above the boats and gives relief to the composition as a whole. The subject is not centred and the empty space between the two boats directs the observer's eye towards the principal element chosen by the artist – the crane.

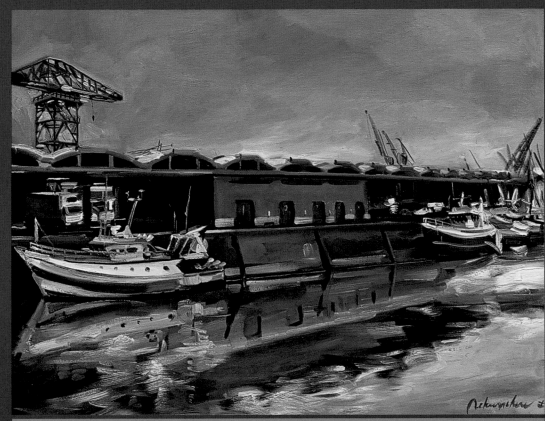

Dieppe, the fishing port. Oil on canvas, 73 x 92 cm (28½ x 36 in).

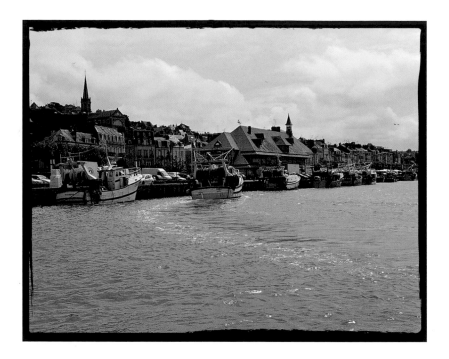

GÉRARD BARTHÉLEMY
Trouville fish market

The mouth of the Touques, the river which separates Deauville from Trouville, is alive with the constant stream of trawlers that come and go with the tide. Gérard Barthélemy has set his easel up in front of this scene, familiar to painters. The original fish market building, characteristic of the neo-Norman architecture of the first half of the 20th century, the many different boats, the limpid sky and the play of reflections on the water, all create an ensemble of shapes and colours that are guaranteed to inspire the artist.

Composition

The quay forms a right angle at the entrance to the harbour, an ideal place for the artist to set up his easel. The composition has a deep perspective created by the horizontal line of the quay, met at the end by the diagonal line of the hill and the rooftops. The back light creates strong shadows along the quay, on the sides of the roofs and beneath the boat hulls. The artist omits certain elements, looking for balance and harmony in the volumes and tonal values that create the atmosphere.

Technique

For a long time Gérard Barthélemy painted with watercolours. He has retained from that time a desire for transparency, for superimposing thin layers and for vivid colours. His oil painting shows the same concern for lightness and careful observation of the individual atmosphere of each landscape. He begins with light colourwashes, looking for the general tonality of the subject matter. Then he gradually covers each area with thicker, more saturated colours. His greys are different mixes based on burnt umber and ultramarine blue enriched with madder lake, yellow or green. There is no white in the first mixes apart from that used in the blue of the sky. The artist works using small strokes of thin paint. He only uses medium in the large flat areas, to make the colour stick to the layers below.

Colours used

Burnt umber, ultramarine blue, madder lake, Mars orange, Rex blue, terre verte, chromium green, yellow ochre, vermilion, Naples yellow, titanium white, ivory black

1 ᵥ Gérard Barthélemy has positioned his easel at the end of the quay, parallel to the subject he is going to paint. He begins by sketching the composition with charcoal.

3 > The artist returns to the drawing with a square brush and a burnt umber colourwash diluted with turpentine. The washes are very pale and delicate.

4 > The square brush is drawn over the surface with short strokes applied with the tip. The shapes gradually become more defined.

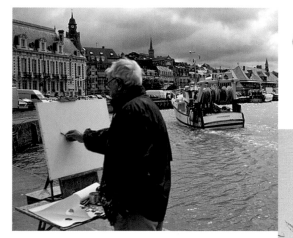

2 > He takes great care over this preliminary work as he is concerned about accuracy of shapes and proportions, endeavouring to create rhythm through the balance of vertical and horizontal lines. Before starting to paint, he lightly rubs out any charcoal lines that are too dark.

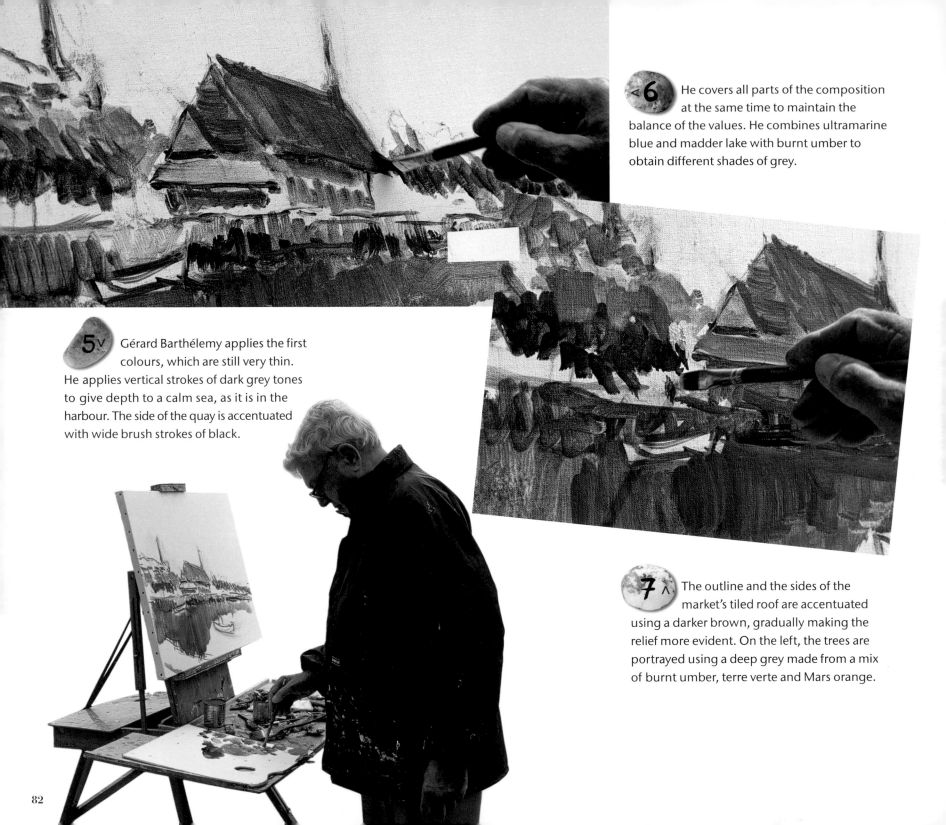

< 6 He covers all parts of the composition at the same time to maintain the balance of the values. He combines ultramarine blue and madder lake with burnt umber to obtain different shades of grey.

5 ⌄ Gérard Barthélemy applies the first colours, which are still very thin. He applies vertical strokes of dark grey tones to give depth to a calm sea, as it is in the harbour. The side of the quay is accentuated with wide brush strokes of black.

7 ⌃ The outline and the sides of the market's tiled roof are accentuated using a darker brown, gradually making the relief more evident. On the left, the trees are portrayed using a deep grey made from a mix of burnt umber, terre verte and Mars orange.

8 All parts of the subject matter are in place with their respective values. The buildings and the clock tower on the left are sketched in a neutral bluish grey. The row of trees lining the quay on the right pick up the deep grey tone mixed with green.

9 The artist turns his canvas upside down to paint the sky, to prevent the paint from running into the areas he has already painted. He prepares a blue-grey made up of white, Rex blue and burnt umber.

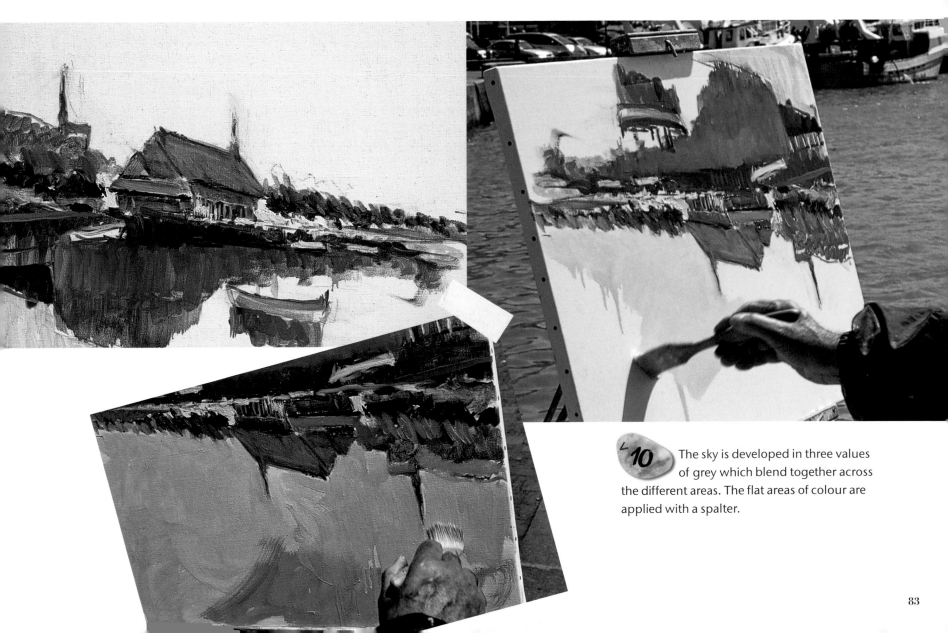

10 The sky is developed in three values of grey which blend together across the different areas. The flat areas of colour are applied with a spalter.

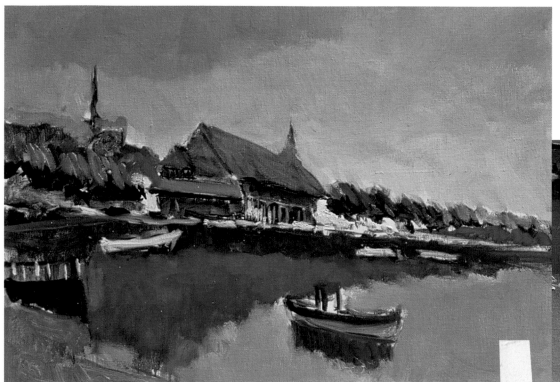

11 The shapes are emerging. The paint is thicker and is applied with superimposed strokes drawn with the tip of the brush. The water in the foreground reflects the sky. It is painted using the same, but slightly heavier, grey-blue tones.

TRADE SECRETS

To draw a mast the artist leans on the handle of another brush held vertically.

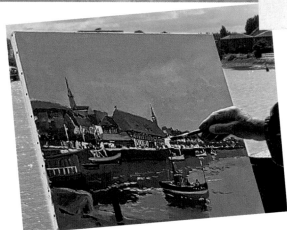

12 Gérard Barthélemy focuses on the details. He chooses a flesh-toned ochre to paint the market hall and the houses along the quay. With small dabs of white, blue and light green he shapes the trawlers alongside the quay and in the foreground.

13 He raises the general tonality of the painting, applying thinner layers of paint. The roof of the market hall is emphasized using a warmer tone, a mix of sienna and orange.

14 He draws the seagulls in the sky and the lapping of the water with a fine paintbrush and small, light, delicate touches of white.

15 > Now the artist turns his attention to the finishing touches. He paints the clock tower and the houses in bluish greys, which emphasizes their distance. Small splashes of Naples yellow, vermilion and green bring life to the sunny quays, the flags and the trawlers. The side of the quay, in shadow, remains very dark.

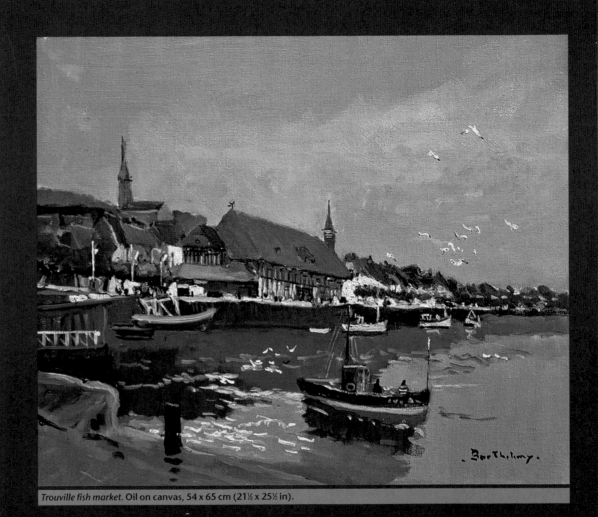

Trouville fish market. Oil on canvas, 54 x 65 cm (21½ x 25½ in).

Gallery

Gazing out towards the sea is a source of infinite pleasure. The sea carries men off in their dreams; it feeds an artist's imagination. The painters brought together in these pages are evidence of this, capturing on canvas the shapes and colours inspired by their emotions. The vast sky, the moving architecture of clouds, the changing colours of the sea, the elongated shape of ships, the bustling activity of ports and harbours are interpreted differently every time. These artists are both painters and sailors at the same time. Some have had long experience of life at sea before picking up a paint brush, others have learned the secrets of the sea on board fishing boats or sailing boats. What they have in common is their love of the sea, an inexhaustible source of inspiration for their talent.

EMMANUEL LEMARDELÉ

Emmanuel Lemardelé was born in Caen in 1948 and studied at the School of Fine Arts in Rouen. He practises drawing and engraving, painting and frescoes. He paints interior scenes and landscapes in series, seeking to reveal different forms and light. The rocky coastlines of Brittany provide strong, unusual images of the earth and of limpid atmospheres. To represent them, Emmanuel Lemardelé uses a mixture of techniques on large format paper mounted on 5 mm plywood on a stretcher. He outlines the subject with a brush soaked in a lightly diluted brown sepia ink wash. Then he paints the rocks and the sea using oil colour sticks. The juxtaposed and superimposed colours retain their luminosity; shadows and light collide in a jumble of rocky cracks and crevices creating a fresh view of the coasts of Brittany.

Brittany. **Diptych, mixed technique, both 100 x 81 cm (39½ x 32 in).**

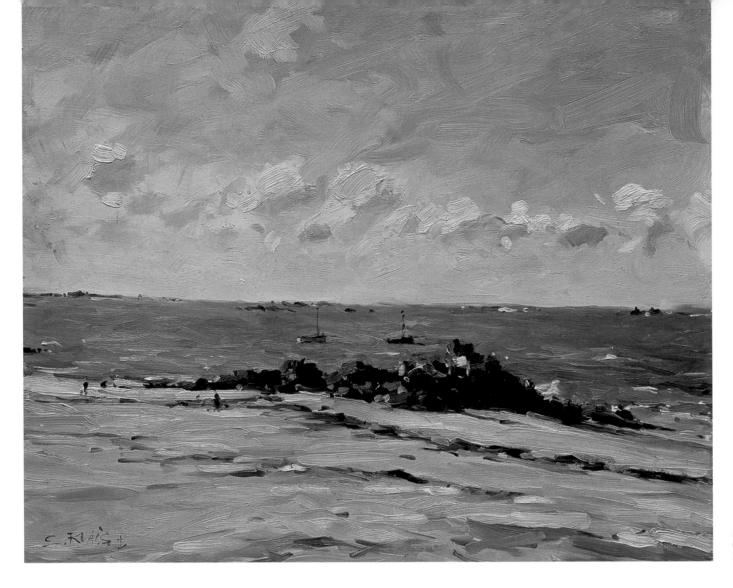

Mooring at Keremma.
Oil on panel,
30 x 40 cm (12 x 15½ in).

STÉPHANE RUAIS
Official Painter to the Navy since 1991

Born in Paris in 1945, Stéphane Ruais is a Fine Arts graduate who specialized in architecture. This training taught him how to look and how to construct. He has happily devoted his time to painting seascapes since 1980. Many hours of sailing along the coast have given him an exceptional knowledge of the sea, of the way the swell forms, of its sudden changes in colour. He works on location, observing the furtive movement of the clouds across the sky. 'You only feel things when you are outdoors', he says. He is particularly fond of wild coastlines where he looks for the interplay of light that emphasizes the relief.

Stéphane Ruais lays down three tones of grey on the blank canvas, never more, and finds the dominant colour of the painting. He captures the subject matter with a large, flat brush, covering the surface quickly. Then he goes back to the shapes with a thicker paint and more precise colours. He does it all very quickly; he must capture the light, memorize its effects and not be affected by changes in the weather. He must steer a steady course.

Jean-Pierre Le Bras
Official Painter to the Navy since 1997

Born at Pleumeur-Bodou in 1931, Jean-Pierre Le Bras is a native of the Trégor region in Brittany, which has always been his home. The shores of the Ile-Grande, of Trégastel, the creeks, the strands, the rocks, the white sand, and the harbours have been familiar to him since he was a child. He started with drawing, but soon started to paint. Self-taught, he follows his instinct for colour and applies it in broad, confident strokes. He shapes the thick paint with a palette knife, which emphasizes the light. Jean-Pierre Le Bras favours isolated places where, all alone, he can feel the beauty that nature offers. Even when he is painting a scene in a harbour he sets up his easel in a quiet place away from the crowd. He makes multiple sketches, which later inspire large paintings in the studio. The luminous greys of the sky, the pinks of the granite rock and the greens and dark blues of the sea create a palette which faithfully reflects the atmosphere of the shores and the harbours that he paints, always with the same enthusiasm and to the same high standards. Each painting captures a moment of truth.

Background light at Perros-Girrec.
Oil on canvas, 54 x 73 cm
(21½ x 28½ in).

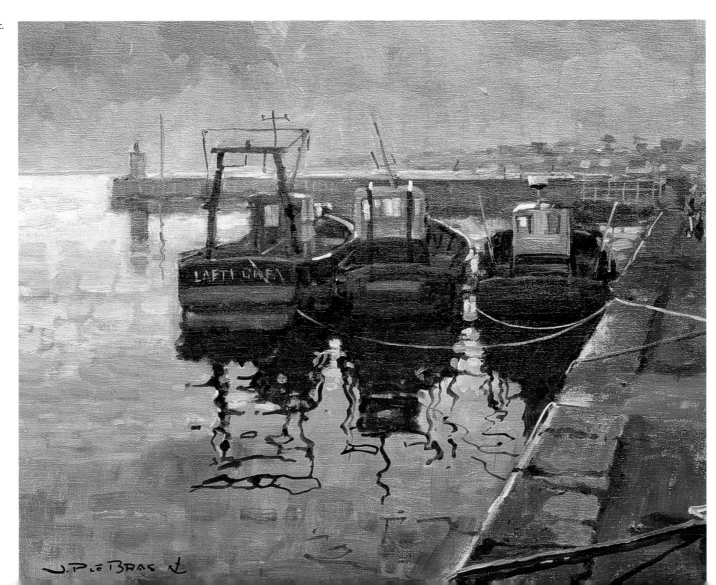

JACQUES COQUILLAY
Official Painter to the Navy since 1995

Jacques Coquillay was born at Châteauroux in 1935. He studied sculpture at the School of Fine Arts in Tours and then at the Paris school in the studios of Marcel Fimon. He gained a postgraduate qualification in the visual arts in 1960. Although he had always practised drawing and painting, it was sculpture that brought him success. In the early 1970s he started on a parallel career as a pastel artist. A need to be in nature regularly took him out of his studio. Sculpture is an art form that demands a lot of time. 'It takes more than a month to develop each piece, during which time I have to keep the flame alight,' he confesses, 'whereas pastel gives me the satisfaction of capturing my emotions at that moment'. Jacques Coquillay loves the pure colour that pastel sticks give him. He admits to a passion for blues, and water – whether it be the sea or a river – is always present in his landscapes. He regularly paints outdoors but does not attempt to describe his subject in detail. The pastel powder settles and the areas of colour blend together in a pleasing harmony, heightened at the last moment by a splash of colour.

Storm over the cliffs. **Pastel on card, 60 x 92 cm (23½ x 36 in).**
© Adagp, Paris, 2006.

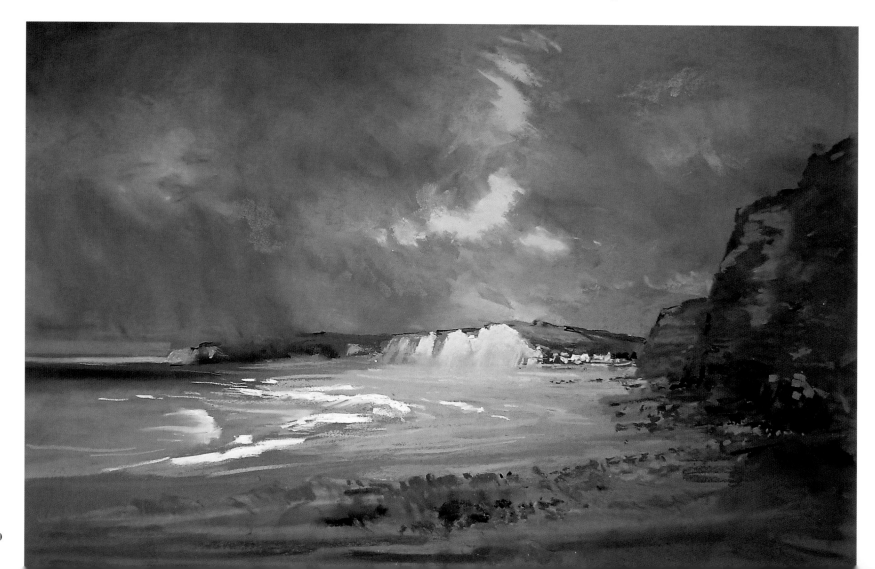

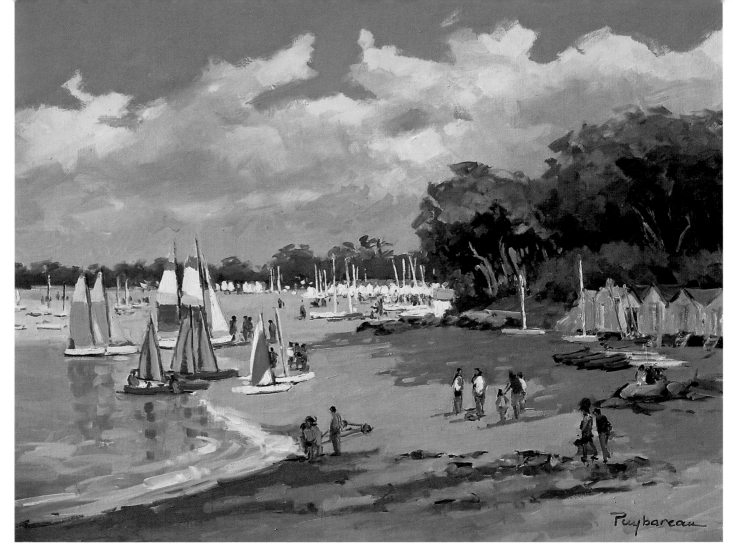

*Noirmoutier, the ladies'
beach.*
**Oil on canvas, 61 x 50 cm
(24 x 19½ in).**
© Adagp, Paris, 2006.

ANNIE PUYBAREAU

Born in Paris in 1955, Annie Puybareau started to draw at an early age. Her family later moved to Rouen and it is there, in the city's School of Fine Arts, that she studied painting with Robert Savary, a painter to the Navy. Appreciative of nature, she works outdoors in all weathers. Her style is allied to the post-Impressionist tradition of the Rouen school. An admirer of Boudin's skies and Monet's seas, she is a painter of the maritime milieu – the banks of the Seine, the colourful beaches of Normandy with people strolling along, the vibrant fishing harbours and chalky cliffs. Her technique is based on a good knowledge of drawing and of the relationship between colours. Her painting is formed of vivid, transparent and contrasting superimposed colours, always finished off with varnish. It all appears to be very easy, yet Annie Puybareau knows that she must not take anything for granted. 'We can't be sure of anything, everything is still to be discovered; that's what's so exciting'. Annie Puybareau's emotions are reflected in her work, where she captures some of the special moments in life.

CHRISTOFF DEBUSSCHERE
Official Painter to the Navy since 1997

Christoff Debusschere was born in Paris in 1962. From a very young age he worked in the studio of his mother, the painter Nicole Lacombe. Gifted and passionate, he later abandoned his accountancy studies and joined the Atelier de la Vigne studio in Étampes, working with Philippe Lejeune. In this hothouse for young talent, Christoff Debusschere learned the 'painter's trade' following a tradition that the master was keen to pass on. It was concerned with understanding form, values and colours, about developing the eye and controlling the touch.

The artist does not make preliminary drawings; he goes straight to the canvas, covering it with large areas of neutral colour, constructing lines and volumes. Light and shade are left till the end. He works quickly; his technique is sparing in both design and colour. Details are merely hinted at. Deserted ports, industrial zones, wastelands, warehouses and warships are his subjects of choice. Above and beyond the subject matter, he likes to feel the soul of such places, where the shadow of those who bring them to life hovers.

The aircraft carrier Charles de Gaulle. Oil on canvas, 130 x 146 cm (51 x 57½ in).

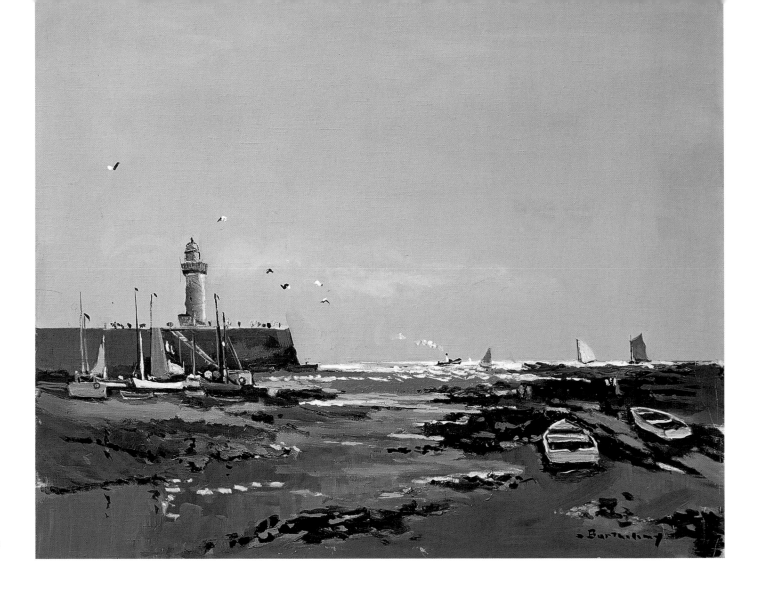

The fleet in Ré.
Oil on canvas, 60 x 73 cm
(23½ x 28½ in).

GÉRARD BARTHÉLEMY

Born on the Ile-de-France in 1927, Gérard Barthélemy is self-taught. An admirer of Cézanne and Marquet, he became fascinated by drawing and landscape painting at a very young age. He got to know Bonnard and the days that he spent in the Le Cannet studio gave him the foundation for what was to become his trade. The winding river Seine, the banks of the Loing and the forest of Fontainebleau were familiar landscapes which always provided him with subject matter for painting. Later he escaped from there to paint the changeable skies and livelier waters of the Normandy coast. He shared with the Impressionists a taste for the variations of light found in nature and for changing reflections. 'The calm of water responds to the serenity of the soul, in the same way that the sky and the water enter into a communion and respond to each other through a finely tuned interplay of blended greys and bluish tones'. Gérard Barthélemy does not try to reproduce real life through the interplay of colours. His painting is sparing, with scant regard for detail. His canvases reveal a contemplative interpretation of the landscape, inspired by his emotions.

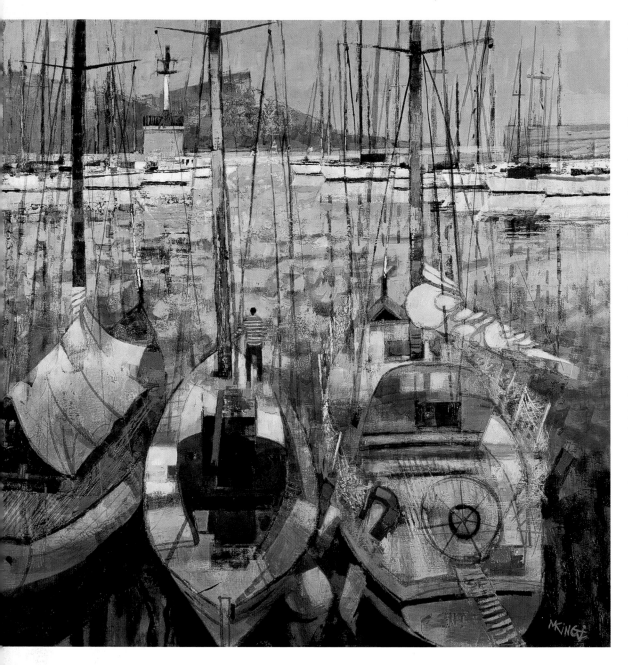

MICHEL KING
Official Painter to the Navy since 1973

Michel King was born in Sotteville-lès-Rouen in 1930. He studied at the School of Decorative Arts in Paris where he worked alongside Gromaire, learning the techniques of etching and lithography – skills which would later enable him to illustrate precious books. The discovery of Brittany in 1950 was a shock to him. Since that time he has never grown tired of painting landscapes with energy and simplicity. King observes the sea and its sparkling effects – the changing colours of the sky reflected on the water, the rocks, the sand and the seaweed through its surface. At the slightest little ripple the sea changes, the mirror cracks. The moment should be identified and memorized. Michel King makes many ink wash or watercolour sketches on location from which he creates large oil paintings in his studio. He attaches a great deal of importance to studying values, 'which enables you to find a subject's light a lot more accurately than by applying colour immediately', he reveals. He applies colour in beige blends, purple pinks and pure blues to celebrate the seascapes of his favourite wild coast.

Sailing boats at Antibes. **Oil on canvas, 120 x 120 cm (47 x 47 in).** © Adagp, Paris, 2006.

CHRISTIANE ROSSET
Official Painter to the Navy since 1995

Christiane Rosset was born in Metz in 1937. Trained as a textile designer, she has devoted herself entirely to painting since the 1980s. She works in her studio from notes and sketches made on location. Her first landscapes were of Brittany. Her palette – sometimes blues and violets, sometimes ochre, yellow and brown tones – expresses her response to the vast shores, the exposed beaches, the meeting of the sea and the sky, with fleeting hints of colour. But very soon her love of travelling took her to new horizons. She travelled the length and breadth of Tunisia, Morocco and Turkey, bringing back numerous sketches that inspired works filled with sparkling colours. An assignment on the frigate Floréal took her to the Kerguelen Islands. She captured life on board a large vessel with Chinese ink and watercolour sketches. Braving the elements, she painted the sea in all its moods and even ventured to paint some more unusual compositions – dark, sheer cliffs and moorland areas inhabited by penguins, elephant seals and albatrosses.

Blue tide in Finistère. Oil on canvas, 162 x 130 cm (64 x 51 in).
© Adagp, Paris, 2006.

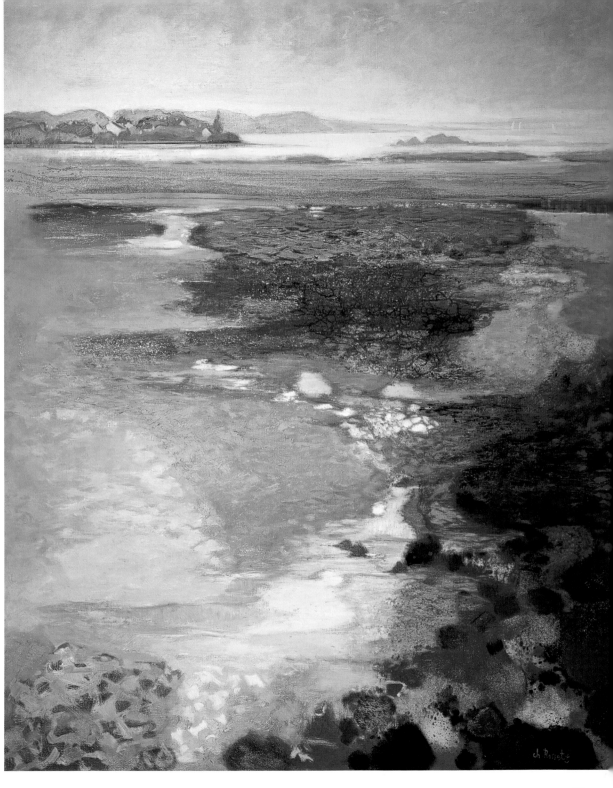

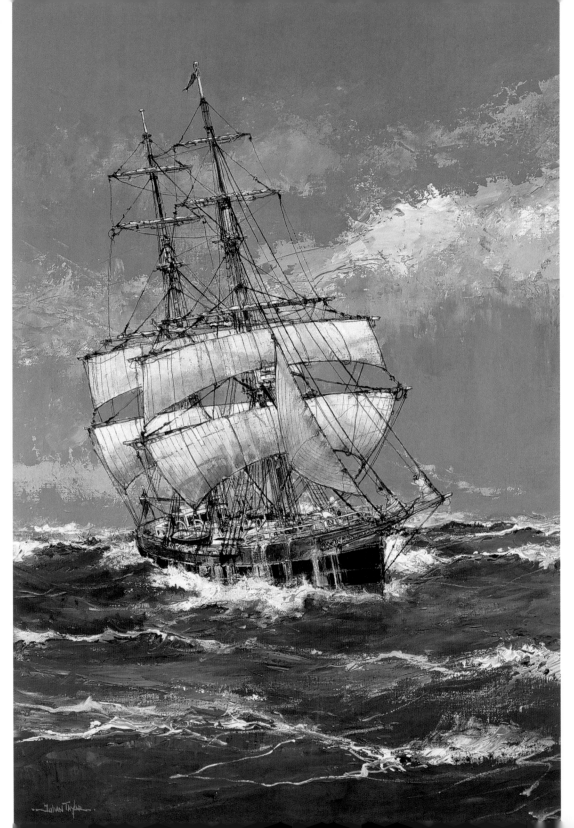

JULIAN TAYLOR

Julian Taylor was born in France in 1954 to British parents. His father, a well-known marine painter, passed on to him a love of the sea and of paint brushes. Brought up in England, Julian took up Fine Arts studies, but quickly abandoned them. He drew, painted landscapes, got married and travelled to India. In 1975 he settled in the Périgord region for good where he continues to paint maritime subjects with passion. 'I transpose, I intellectualize – especially as I do not paint from real life', he admits. He travels around the coast armed with a camera and a sketchbook, bringing back images which will be the inspiration for his canvases.

Julian Taylor paints in acrylics. He begins by positioning the main elements using a very fine brush and an umber colourwash. He covers the whole composition with colourwashes, then applies stronger and thicker colours with a brush or a knife, covering some parts of the painting with a mix of plaster and acrylic to create a little relief. When all the colours are in place he picks up the details with brighter tones and draws the most significant elements of the scene with the tip of the brush.

Julian Taylor, *Brig and rough sea.*
Acrylic on canvas, 92 x 65 cm (36 x 25½ in).
© Adagp, Paris, 2006.